# SKIING
IN
COLORADO

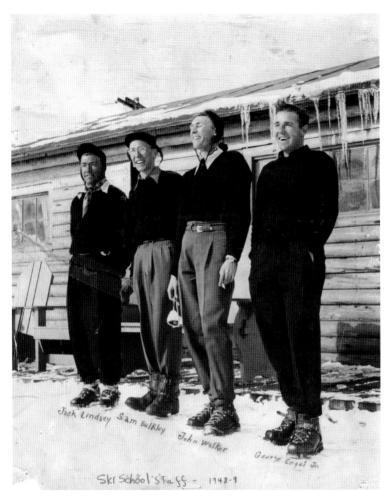

SKI SCHOOL STAFF, 1948–1949. This photograph shows, from left to right, Jack Lindsey, Sam Bulkley, John Walker, and George Engel Jr., Winter Park Ski School instructors. (Courtesy of the Colorado Snowsports Museum.)

ON THE FRONT COVER: Taken on Vail Mountain in the 1960s, this photograph shows a Vail employee jumping in powder. Christie Hauserman is credited with designing the famous "Vail stripe" prominently featured on all employee uniforms, seen here on the jacket. (Courtesy of the Colorado Snowsports Museum.)

ON THE BACK COVER: This c. 1960s photograph taken at Eldora shows Eva Cseh Distel, wife of Gabor Cseh, one of the founders of Eldora. (Courtesy of the Colorado Snowsports Museum.)

COVER BACKGROUND: Showing the double chairlift, this photograph was taken at Loveland Ski Area around 1955 to the 1960s. (Courtesy of the Colorado Snowsports Museum.)

# SKIING IN COLORADO

*Colorado Snowsports Museum and Hall of Fame
and Dana Mathios*

*The images in this book come from the Colorado Snowsports Museum's permanent photograph archive, established in 1975.*

Copyright © 2023 by Colorado Snowsports Museum and Hall of Fame
ISBN 978-1-4671-6055-1

Published by Arcadia Publishing
Charleston, South Carolina

Printed in the United States of America

Library of Congress Control Number: 2023939831

For all general information, please contact Arcadia Publishing:
Telephone 843-853-2070
Fax 843-853-0044
E-mail sales@arcadiapublishing.com

Visit us on the Internet at www.arcadiapublishing.com

# CONTENTS

| | | |
|---|---|---|
| Acknowledgments | | 6 |
| Introduction | | 7 |
| 1. | Miners, Mailmen, Medics, and More | 9 |
| 2. | Lift Advancements and Snow Grooming | 21 |
| 3. | National Ski Patrol History | 29 |
| 4. | Pre–World War II Resorts | 39 |
| 5. | 10th Mountain Division and Colorado Skiing | 45 |
| 6. | Colorado Ski Resorts Post–World War II | 51 |
| 7. | Abandoned and Lost Resorts | 67 |
| 8. | Early Adaptive Pioneers | 75 |
| 9. | Colorado-Based Snow Sports Brands | 85 |
| 10. | Colorado Competition Champions | 101 |
| About the Organization | | 127 |

# ACKNOWLEDGMENTS

The Colorado Snowsports Museum and Hall of Fame would like to thank our supporters. If it were not for you, we would not be able to fulfill our mission to celebrate Colorado snow sports by telling stories that educate and inspire others to seek adventure. Furthermore, we want to thank the many people who helped build our snow sports industry—veterans, immigrants, families, athletes, ski bums, pioneers, risk-takers, and adventure-seekers.

We would also like to extend our sincerest thanks and appreciation to our staff and volunteers for preserving Colorado's rich snow sports history. Thank you to Jennifer Mason, Dana Mathios, Susie Tjossem, John Dakin, Patricia Ann Pfeiffer, Jim Dunn, and our current and past board of directors. Sending our gratitude to all board members who helped with the process of this book project: Diane Boyer, Thomas Hames, Dean Ericson, and Trent Bush. Without their continued support, we would not be able to share this snow sports heritage with you all.

Dana Mathios, curator and director of collections with the museum, was able to take the preservation work done since 1975 and meld it with photographs donated to the institution to curate a glimpse of what skiing in Colorado was and continues to be. If not for the tireless hours saving newspaper clippings, writing biographies, completing donation records, collecting photographs, managing metadata, and more, this book could not have been created. Mathios gives special thanks to the archivists, collections managers, curators, and volunteers of the museum's past.

Unless otherwise noted, all photographs in this book are from the Colorado Snowsports Museum's photograph archive. Thank you to our donors and hall-of-fame members for helping us build this archive over the years.

# INTRODUCTION

Skiing in Colorado has grown from being a necessity for only a few, to a world-class recreational pursuit. Scandinavians, Canadians, Europeans, and other immigrants who came to Colorado to work in mining camps and towns brought skiing to the state. The first documented use of skis in Colorado occurred during the winter of 1859–1860 in a mining camp near present-day Breckenridge, at the base of the Rocky Mountains' Tenmile Range. By the following winter, almost all provisions were carried over the mountains on skis.

During these early days of skiing, miners, medics, mailmen, ministers, and even farmers used skiing as a mode of transportation. In the 1880s, skiing became a competitive sport in the mining towns of Gunnison County. On Christmas Day 1881, a total of 25 skiers raced a quarter of a mile for a $25 prize. Miners in Gunnison formed one of Colorado's first ski clubs. By 1886, a racing circuit of skiers from mining towns had been established. The circuit did not last long though, as mines played out and miners moved on to bigger strikes. Forty years would pass before ski racing caught on again in Colorado.

The popularity of skiing grew in the early 1900s, as ski jumping and ski clubs became more common. Early ski jumping competitions took place in areas like Howelsen Hill in Steamboat Springs and Dillon in Summit County.

As skiing became more popular, people began to understand the risks and the many injuries that can accompany participation in the sport. This led to the creation of the National Ski Patrol System.

In the 1930s and 1940s, ski areas sprang up throughout Colorado. At this time, areas like Howelsen Hill, Berthoud Pass, and Loveland Ski Area were established. Once World War II started, the growth of skiing and ski resorts took a pause, because many skiers joined the US Army's elite 10th Mountain Division. Once these individuals came back postwar, many to Colorado, they helped improve the snow sports industry and kick-start the modern ski industry.

Postwar Colorado saw a boom in the snow sports industry with advancements in equipment, ski school development, collegiate skiing, the opening of new ski areas throughout the state, advanced lifts, increased inclusion, and more. Competitive collegiate skiing originated in the eastern United States and expanded west in the 1940s. Colorado schools have dominated ever since and continue to succeed in competitive skiing.

In addition to the many new ski areas that sprang up across Colorado, the state has also seen many areas become dormant. These areas are referred to as lost or abandoned resorts. Today, several of these areas are enjoyed by backcountry enthusiasts. They are no longer recognized as resorts but rather as recreational areas. With the opening and closing of ski areas across Colorado, there were plenty of opportunities to advance how people got to the top of ski hills.

As skiing innovation improves, the sport also becomes more inclusive and accessible. Adaptive skiing allows people with disabilities to ski using specialized equipment. Colorado led the way in disabled skiing when 10th Mountain Division veteran Jim Winthers taught two amputee veteran

friends how to ski. With the support of other veterans, Winthers founded Disabled Sports USA in 1967. Adaptive skiing soon grew into a competitive sport, with 17 skiers participating in the first championships in Austria in 1948.

As skiing advanced, so did its equipment. It should be no surprise that many people from Colorado helped create innovative gear and clothing, with women playing a vital role.

The close of this book celebrates the numerous athletes representing Colorado in competitive skiing throughout history, from ski jumping to Alpine ski racing. These pioneers set the stage for the next generation of skiers.

# 1

# MINERS, MAILMEN, MEDICS, AND MORE

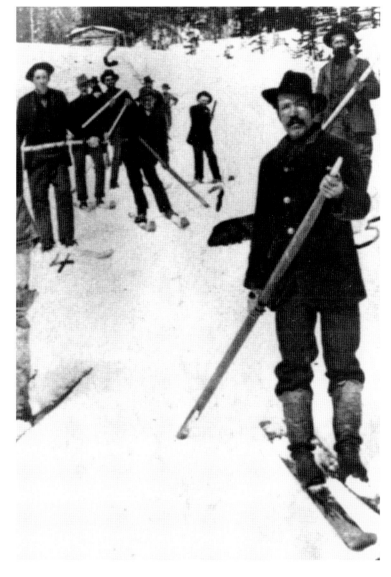

AL JOHNSON, 1880S. Nine-foot-long skis were superior to snowshoes in the deep, powdery snow of the high mountains. Mail carrier Albert "Al" Johnson (front) was one of the best skiers in the Elk Mountains, a high, rugged range in the Rocky Mountains of west-central Colorado. Johnson, a native Canadian, was a superb skier before he came to Crystal, Colorado, in 1880 to prospect for silver.

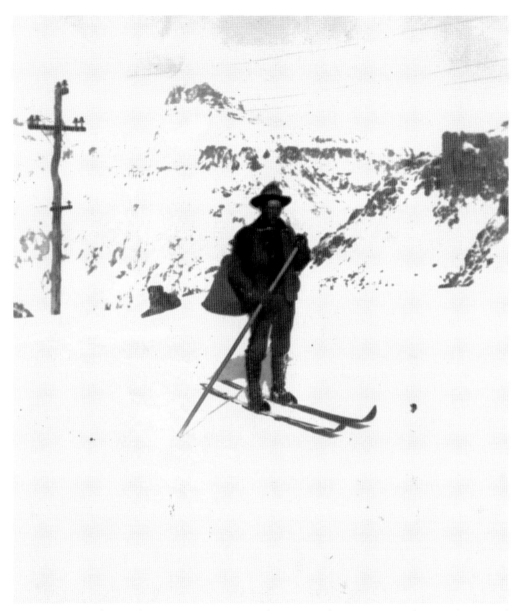

**HUMBOLT MINE (OURAY) MAILMAN, 1912.** As early as 1880, there were more than 50 skiing mail carriers in Colorado. Using rudimentary skis and bindings, and carrying mail sacks weighing more than 25 pounds, they traveled 50 miles at a stretch through the mountains. Early skiers used a single pole for balance, turning, and braking. Many of Colorado's early skiers were people who had to travel between remote communities. Mail carriers, ministers, and doctors braved blizzards, avalanches, deep snow, and even deeper drifts to reach isolated towns and homes. Some died and others lost fingers and toes to frostbite while providing a lifeline to the outside world. Ministers like Fr. John Dyer took the word of God to remote communities and rough-and-tumble mining camps. Doctors had to ski to reach isolated patients. Dr. Vernon Solandt made house calls on skis in Steamboat Springs from 1897 to 1916.

HOT SULPHUR SPRINGS CARNIVAL, 1912. During the 1911–1912 winter season, John Peyer started the first winter carnival in Hot Sulphur Springs. To the surprise and delight of all attending, Norwegians Carl Howelsen and Angell Schmidt skied down Rollins Pass into the carnival. Howelsen built a ski jump and demonstrated ski jumping to the amazed townspeople, who made jumping part of their annual carnival.

HOWELSEN PRE-JUMP, C. 1915. Carl Howelsen later introduced ski jumping to the town of Steamboat Springs, where he built the community's first ski jump and organized its first winter carnival in 1914. He jumped 108 feet, winning the competition. Winter carnivals exposed Coloradans to Nordic skiing, ski jumping and racing, and skijoring, as well as the value of recreational skiing.

PETER PRESTRUD. Peter Prestrud settled in Frisco in 1910. He and friends built one of the state's first ski jumps on nearby Tenmile Creek. Thus began a long series of jumping enterprises that benefited from his direction, including Inspiration Point, Genesee Mountain, Allen's Park, Leadville, Homewood Park, Pike's Peak, Estes Park, and others. A close friend of Carl Howelsen and an enthusiastic competitor, Prestrud once skied 55 miles across Ute Pass to participate in a meet at Hot Sulphur Springs. He was the Colorado amateur jumping champion in 1921. The ski jump hill at Dillon, one of the state's best, was renamed Prestrud Hill in 1954 in his honor.

**HOWELSEN (FAR LEFT).** When Denver newspapers printed a story on Carl Howelsen ski jumping in Steamboat Springs, the sport exploded in popularity and Colorado became a mecca for jumpers. Born in Norway, Howelsen first jumped at the famed Holmenkollen in 1895. By 1904, he had emerged as one of Norway's prime ski competitors, winning the gold medal that year at the Holmenkollen and the Crown Prince Silver Cup. Like many Europeans around the turn of the 20th century, Howelsen immigrated to the United States. In 1914, he helped expand their ski jumping and Nordic activities. Howelsen later returned to Norway in 1922, yet his name is synonymous with ski jumping in Colorado. The famed ski jump hill of Steamboat Springs is named in his honor—Howelsen Hill.

STEAMBOAT SPRINGS, 1925. Skijoring began in Scandinavia, where reindeer pulled skiers. In Colorado, horses replaced reindeer. Skijoring has evolved into a competitive sport, where the horse, rider, and skier navigate a course of gates and jumps. Sleigh rides, horse slalom, and other horse events were popular at winter carnivals.

STEAMBOAT WINTER CARNIVAL, 1977. This photograph shows a horseback slalom race. During the winter carnival, local ranchers, cowboys, and skiers turn out to show visitors how winter is celebrated in the mountains. The town celebrates the oldest winter carnival in the western United States each February, featuring various competitive events.

**PIKES PEAK SKI CLUB, 1930s.** In addition to early ski pioneers and events, Colorado ski clubs led the way in advancing the sport of skiing. Donald Lawrie organized the Pikes Peak Ski Club in 1936 and served as president for 10 years. That same year, he conceived and installed the first mechanized tow in Colorado at Glen Cove, a rope tow powered by an old Whippet car engine. Pikes Peak was the major ski area in Colorado Springs from 1939 to 1984.

COLORADO ARLBERG CLUB MEMBERS. Colorado's early ski clubs contributed to the popularity of skiing and the growth of the ski industry. The Hot Sulphur Springs Winter Sports Club was Colorado's first organized ski club. In 1929, the Colorado Arlberg Ski Club was formed by a group of skiers, most of whom were members of the older Colorado Mountain Club. There were nine founders, including Garret B. Van Wagenen and Graeme McGowan.

ARLBERG CLUB MEMBERS, 1938. The Colorado Arlberg Club ran the first ski races in 20th-century Colorado, including the first modern slalom race in 1931. Adolph Coors III, the grandson of the founder of the Coors Brewing Company, was one of the earliest members of the Arlberg Ski Club at Winter Park, joining in 1938. The club held races until 1941 when the United States entered World War II.

**WINTER PARK SKI TRAIN, 1976.** In 1939, Frank Bulkley started the Eskimo Ski Club to teach Denver children to ski. He used the Winter Park Ski Train to carry some 300 children from Denver to and from Winter Park every weekend. The Winter Park Ski Train was instrumental in bringing ski clubs and the public to Colorado's slopes. After serving in the 87th Mountain Infantry of the 10th Mountain Division during World War II, Bulkley resumed his involvement with the Eskimos and began a ski shop, which was the first in Denver to offer seasonal rentals. His contributions to snow sports undoubtedly increased the growth of skiing in Colorado. In the mid-1950s, a total of 33 ski trains were operating in Colorado.

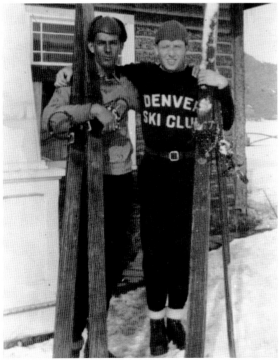

**Denver Ski Club, c. 1930s.** Ski clubs continued to emerge across the state. During World War II, the 10th Mountain Division was the only US military unit to be recruited by civilian entities and snow sport clubs: the Denver Ski Club and the American Alpine Club, for example. Minnie Dole, the founder of the National Ski Patrol and the 10th Mountain Division, recruited skiers from the National Ski Patrol and college ski teams. Dole observed that there were two million equipped, intelligent, and able skiers. He contended that it was more reasonable to make soldiers out of skiers than skiers out of soldiers. He recruited ski instructors, mountaineers, and outdoorsmen.

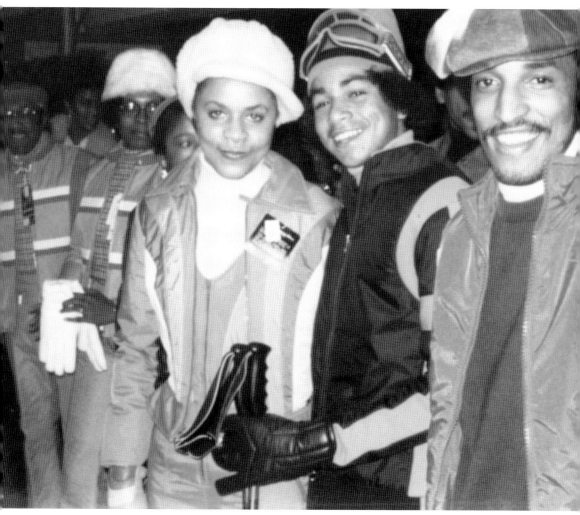

SLIPPERS-N-SLIDERS, C. 1970S. Colorado ski clubs have evolved from being social and recreational to training some of the most elite soldiers and competitors in the world, while also promoting skiing to an increasingly diverse population. Ski clubs have helped make snow sports more inclusive. Chartered in 1974 and incorporated as a nonprofit organization in 1975, the National Brotherhood of Skiers (NBS) is a nonprofit group that represents Black skiers, riders, and snow sport enthusiasts across the nation. The NBS is comprised of dozens of clubs in the United States, including many in Colorado like the Slippers-N-Sliders Ski Club of Denver, Ski Noir 5280, BIPOC Mountain Collective, and the Ski Ambassadors of Colorado Springs. The NBS's mission is to identify, develop, and support athletes of color who will win international and Olympic winter sports competitions representing the United States and to increase participation in winter sports.

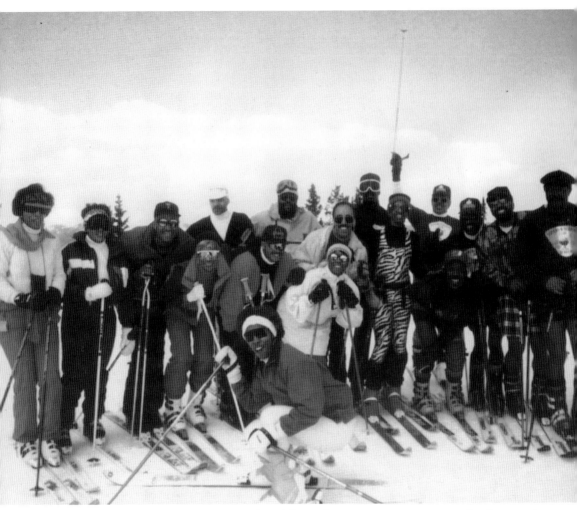

BLACK SKI SUMMIT, C. 1990S. At a time when African Americans were a rarity on the slopes and Black ski clubs were an exception, founders Ben Finley and Art Clay met in 1972 and were not deterred from their vision to create a national Black summit for skiers. One year later, the historic first Black Ski Summit gathering took place in Aspen in 1973 and was attended by over 350 skiers from all over the country. The overall sense of camaraderie and connection that pervaded the event still holds true today. The NBS celebrated its 50-year anniversary in Vail in February 2023. After decades of bringing together and empowering thousands of Black snow sport enthusiasts across the country, the groundbreaking organization continues to promote positive change in the outdoor industry and change perspectives about who belongs on the slopes.

# 2

# LIFT ADVANCEMENTS AND SNOW GROOMING

WINTER PARK T-BAR, C. 1948. One of the earliest advancements in skiing was how people got up the hill. Colorado was home to many firsts for lift technology. In addition, snow grooming in Colorado has a storied past. Many innovative ski pioneers worked on manipulating snow for recreational use in Colorado, but one story stands out in history: that of the Bradley Packer-Grader.

**BERTHOUD PASS ROPE TOW, 1938.** As far back as the 1920s, miners in Telluride rode ore buckets uphill and skied down to return home. As skiing's popularity grew in the 1930s and 1940s, ski areas sprang up throughout Colorado. Although most were short-lived, they provided a proving ground for new ways to get skiers to the top of the hill. In 1936, Aspen locals built a six-passenger boat tow using a Studebaker car motor, two old mine hoists, and two 10-person sleds. On opening day, 100 people rode Colorado's biggest ski lift at the time. The fee was 10¢ a ride or 50¢ for a half day. From then on, Colorado has been a place for lift innovation. In 1937, Berthoud Pass installed an 878-foot-long rope tow at the summit of the pass. In 1939, the Gunnison Ski Club erected the first single chairlift in Colorado at the Pioneer Ski Area, five miles south of Crested Butte. It was made from old mining tram parts. That same year, Winter Park added its first J-bar tow.

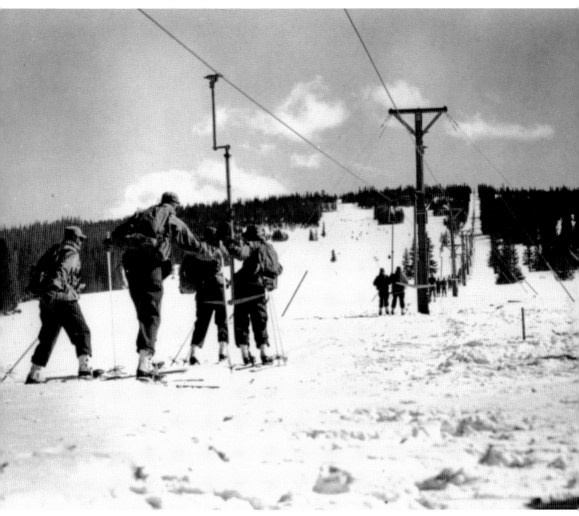

**10TH MOUNTAIN DIVISION USING T-BAR, 1940S.** By 1942, the Army had installed the world's longest T-bar (6,000 feet) on Cooper Hill. Soldiers of the 10th Mountain Division learned to ski and train here. This hill is just outside of Camp Hale, home of the 10th Mountain Division of World War II and a national monument. The ski area is now known as Ski Cooper. By 1945, after World War II, two additional rope tows were added to service upper mountain trails at Winter Park. A T-bar lift was added to Winter Park by 1948, which brought the lift system to three T-bars and four rope tows. During the 1953–1954 season, Arapahoe Basin installed the first Poma lift in the United States. A few years later, Winter Park installed two T-bars in 1957 that were said to be the fastest in the world (820 feet per minute). By 1961, Peak 8 at Breckenridge opened with a 6,200-foot double chairlift that could carry eight hundred skiers per hour.

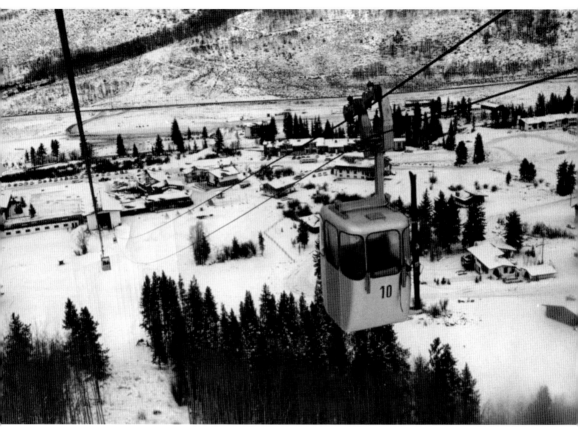

**COLORADO'S FIRST GONDOLA, VAIL, 1962.** Vail opened on December 15, 1962, featuring Colorado's first gondola (four-passenger), two double chairlifts, and a short Pomalift. This gondola opened just months before Crested Butte installed its first gondola. Almost two decades later, Breckenridge leads the way with more firsts. In 1981, it was the first ski area in North America to install a high-speed, detachable quad chairlift that covered one mile in seven minutes. By 1990, Breckenridge had the first Magic Carpet, a beginner-friendly alternative to tow-type devices. Breckenridge installed North America's first six-passenger double-loading chairlift, Quicksilver Super 6, in 1999. By 2005, it installed the highest lift in North America (12,840 feet), Imperial Express. At other resorts throughout the state, more innovations were being installed. In 1996, Telluride installed the nation's first free pedestrian gondola, connecting Telluride to Mountain Village. Meanwhile, Purgatory Resort installed Colorado's first Doppelmayr six-person chairlift. In 2014, Beaver Creek installed a chondola, which alternates chairs and gondolas on one line and was the first of its kind in the United States.

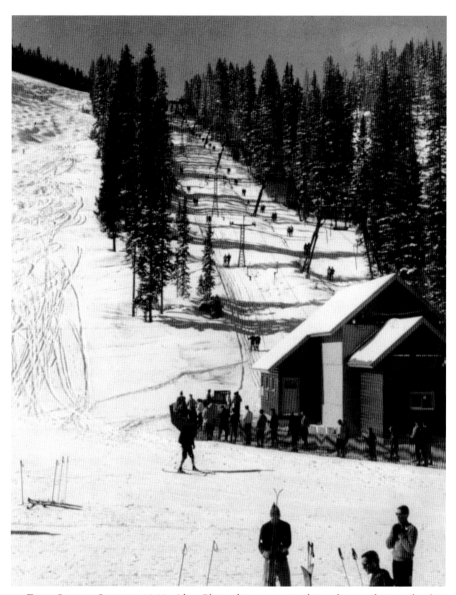

**WINTER PARK LOWER LODGE, 1968.** Alan Phipps's interest in skiing began during the formative years of the sport in Colorado. It was through his efforts that Denver's city council authorized the creation of the Winter Park Association, a nonprofit agency, to operate the ski area independently from the city. He was elected chairman of the board of trustees for the newly created association and maintained that position until he stepped down as chairman on Winter Park's 30th anniversary in 1969. With Phipps's guidance, Winter Park grew into an internationally acclaimed ski resort with 18 chairlifts. In 1950, the area had only three T-bars and four rope tows. For 37 years, Phipps was an active leader in the development of Winter Park programs, including an extensive expansion project, the fostering of slope grooming, the development of a nationally known jumping school, and the world's largest adaptive program. At the age of 75, Phipps remained an active member of the Colorado Arlberg Club, which he joined in 1936.

**STEPHEN BRADLEY.** At the same time Alan Phipps started improving Winter Park, Stephen Bradley also joined the team. Bradley's talents for ski sport leadership and innovation showed up at an early age. While attending Dartmouth, he became a four-way specialist competing in slalom, downhill, jumping, and langlauf from 1937 to 1939. World War II service was followed by studying and ski coaching at Colorado University. The year 1950 saw the beginning of Bradley's distinctive service as executive director of the Winter Park Recreational Association. During succeeding years, he brought Winter Park from a four rope-tow, three T-bar ski area to one consisting of 770 acres served by 13 lifts. His design for Balcony House, the base lodge, was one of the first ski area structures to utilize solar heating; his contribution to the design of Snoasis, the midway restaurant, provided a model for the "scramble" system of food service.

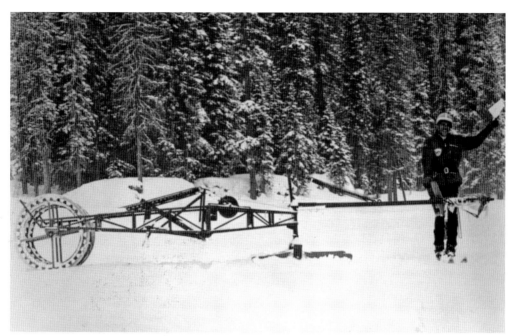

**BRADLEY PACKER-GRADER, C. 1950S.** Stephen Bradley's pioneering experiments with slope grooming led to the design of the famous Bradley Packer-Grader, a man-powered slope grooming device that revolutionized that facet of the ski industry and led to his nickname, the "Father of Slope Maintenance." In June 1950, Bradley, while working at Winter Park, began working with Ed Taylor on ideas for stabilizing and leveling the snow surface, especially moguls. At the time, Winter Park manually smoothed these bumps by sending out teams with shovels. By the close of the year, Bradley had built a roller design that became known as the Bradley Packer-Grader.

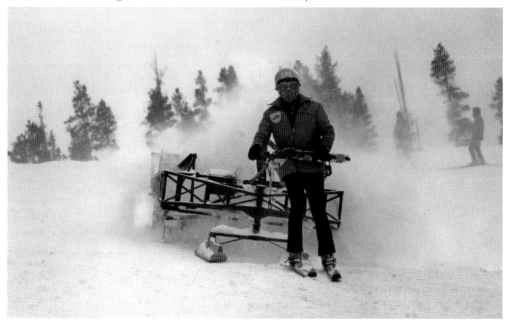

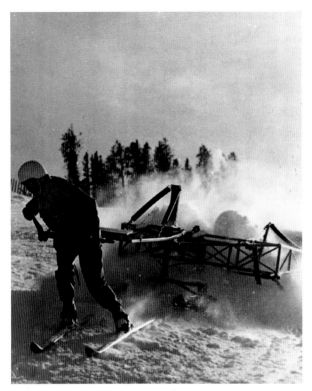

BRADLEY PACKER-GRADER, c. 1950s. By 1951, the new grooming machine started to be seen as a success. It was gravity-powered and steered by a skier who was rumored to make 25¢ per hour, which was more than the trail crew wage at the time. The machines were of a slat roller design and weighed 700 pounds. It had the effect of packing half the snow and powdering the rest for a soft, skiable surface. In front of the roller, Bradley put an adjustable steel blade, spring-loaded to shave the tops off moguls. The drivers were completely dependent on the blade for speed control.

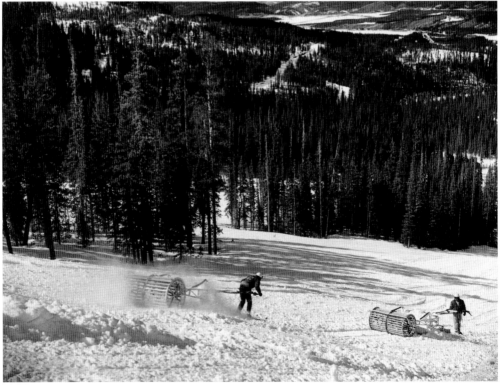

# 3

# NATIONAL SKI PATROL HISTORY

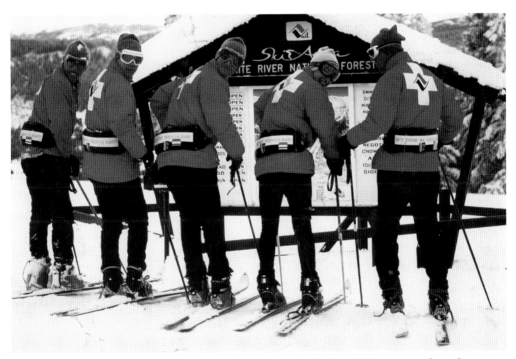

VAIL SKI PATROL, C. 1960S. As useful as it is to get up the hill and ski on smooth trails, getting down the slopes in an emergency is imperative. Another significant improvement in skiing history was helping keep people safe and assisting them in the event of an injury on the mountain. There are several Colorado connections to the National Ski Patrol and numerous standout ski patrollers who have contributed to keeping Colorado mountains safe.

CHARLES "MINNIE" DOLE, C. 1940S. In 1936, Charles Minot "Minnie" Dole shattered his ankle skiing in Vermont. Alone on the mountain with no help available, Dole learned first-hand that there was a need for a trained group of skiers to offer aid on the mountain. In 1938, he organized volunteer skiers to help with the national downhill races. The National Ski Association was so impressed that Dole was asked to develop and manage a similar program at the national level—the National Ski Patrol System (NSPS). Today, the NSPS, headquartered in Lakewood, Colorado, is the world's largest winter rescue organization, with more than 31,000 members. The ski patrol prepares the mountain for opening by setting up equipment, conducting trail checks, and conducting in-bounds avalanche control. It develops new safety and rescue techniques to keep pace with evolving skiing and snowboarding technology and increase access to the backcountry. It also conducts an end-of-day sweep to ensure the mountain is free of people.

WILLIAM "BILL" JUDD, C. 1950s. When one thinks of ski patrollers who made an impact on the state of Colorado, Bill Judd comes to mind. Judd was born in Denver in 1917 and was educated at the University of Colorado. In addition to becoming an engineering geologist, consultant, and educator, Judd forged a career in ski safety. In 1938, he organized the first ski patrol at Hidden Valley and was head of the patrol for several years. He went on to direct patrols at Berthoud Pass, Loveland, and Arapahoe Basin. Judd was Rocky Mountain Division chairman for the NSPS, wrote the ski patrol column for *Rocky Mountain Skiing*, and was the NSPS Outstanding Patrolman from 1951 to 1952. The year 1957 saw Judd as the national director for the NSPS. Subsequent years saw Judd's involvement expand, as supervisor of the ski patrol for the International Ski and Snowboard Federation (FIS) world championships at Aspen (1950), organizer of the patrol for the Olympic tryouts (1959) and the Olympic Winter Games (1960), finance chairman for the Southern Rocky Mountain Ski Association (1940–1950), and recipient of the Halstead Trophy (1954).

**HANS BOOKSTROM, C. 1950s.** Bookstrom was an active and resolute volunteer in Colorado skiing from 1942 to 1969. Between 1944 and 1957, he served as patrol leader at Berthoud Pass, leader of the Denver Metropolitan Ski Patrol, and section chief, regional chairman, and divisional chairman of the National Ski Patrol. He taught first aid for ski patrollers for 25 years and put his first-aid skills to use every weekend. Bookstrom also taught avalanche control and rescue. In 1947, he became increasingly involved with competitive skiing for Colorado junior skiers. He became a sponsor, driver, and coach for the Junior Ski Club Zipfelberger, a certified referee, and a particularly good waxer for both Alpine and Nordic events. As the Denver-based ski patrol gave way to ski area–led patrols, Bookstrom joined the Winter Park Ski Patrol and Jumping School. He became a national jumping judge and continued to inspire young skiers to become ski patrollers and competitors.

LOU LIVINGSTON. If there is one individual who made skiing and ski patrol his life in Colorado, it would be Lou Livingston. Livingston is almost a Colorado native, arriving from Chicago in Estes Park at the age of two weeks. He put on his first pair of skis at age four. At age 18, he joined the National Ski Patrol as a volunteer for the Boulder Ski Patrol, and in 1997, received a commendation for 50 years of service. He was a representative of the Rocky Mountain Division board of directors and served on the ski patrols of Vail (as a volunteer on its first ski patrol), Winter Park, Arapahoe Basin, Berthoud Pass, and Loveland. Livingston was one of the founders of the Colorado Snowsports Museum and was a board member of the Ski & Snowboard Club Vail. He served in many ski patrol leadership positions, including section chief, regional director, assistant division chairman, Rocky Mountain Division representative to the NSPS national board, and NSPS ombudsman.

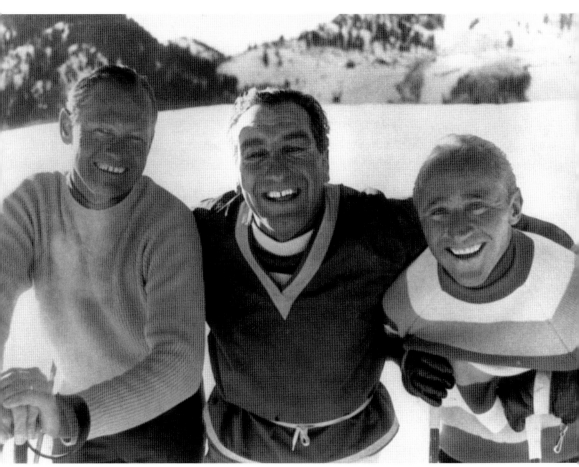

ASPEN ICONS, C. 1950S–1960S. This photograph shows Morrie Shepard, Fred Iselin, and Anderl Molterer. Shepard grew up in Maine where he was a friend of Pete Seibert, the founder of Vail. The boys skied together from age seven. During World War II, Shepard was a US Navy pilot, and after the war, he joined Seibert in Colorado, where the two became members of the Aspen Ski Patrol. After that first winter, Shepard moved to the ski school and eventually became assistant ski school director to Fred Iselin and Friedl Pfeifer. From 1956 to 1960, he was an examiner for the Rocky Mountain Ski Instructors Association and became chief examiner from 1960 to 1965. Shepard left Aspen to join Pete Seibert as he built and launched Vail. He helped lay out the trail system and got deeply involved in the gondola construction and other mountain projects. In the fall of 1962, he assumed his duties as Vail's first ski school director. In 1960, Molterer moved to Aspen and worked as ski racing director for the Aspen Skiing Company.

TIMING CLINIC, C. 1950S–1960S. Harold Horiuchi started as a ski patrolman at Winter Park in 1951 and was patrol leader from 1963 to 1964. He was a member of the Tyrol Ski Club from 1950 to 1960, serving as president in 1955. Horiuchi lent his talents and energy to improving the organizational aspects of both recreational and competitive skiing. He became a certified official for races, conducted classes for the certification of race referees and official timers throughout the Rocky Mountain Ski Association, served as an official timer at the 1960 Winter Olympics, and instigated sanctioned racing at Winter Park. He co-authored the *Manual Timing* book and was an active member of the Ski Club Zipfelberger. He served two terms as president of the Rocky Mountain Ski Association in 1959 and 1960, received a National Ski Association citation for Distinguished Service in 1961, and received the Rocky Mountain Halstead Memorial Award in 1962. This photograph shows Horiuchi (far left) hosting a timing clinic.

SCHOBINGER NATIONAL DIRECTOR, 1962–1968. Experience as a scout leader and first aid instructor led Charles Schobinger to volunteer for membership in the Arapahoe Basin Ski Patrol in 1955. He went on to impact skier safety in Colorado and the United States. He and fellow patrolman Raymond E. "Bud" Law earned the Purple Merit Star for saving a skier's life. Schobinger went on to become president of the National Ski Patrol (1962–1968) and serve on the boards of the United States Ski Association and Professional Ski Instructors of America. Schobinger designed the original uniform ski trail marking signs (the square, circle, triangle, and diamond) and drafted the original wording of the National Skiers Courtesy Code. In 1970, the National Ski Patrol System established the Charles W. Schobinger National Administrative Award and granted him lifetime membership when the patrol celebrated its 50th anniversary in 1988.

AXLEY GIVING SPEECH, C. 1960S. Another impactful ski patroller is Hartman "Hart" Axley, who has been involved for more than a half century with all facets of skiing. The NSPS appointed him national ski patrolman No. 1413. Moving to Colorado in 1956, Axley patrolled Arapahoe Basin for 29 years and was a member of three outstanding ski patrols: Denver Metropolitan Ski Patrol (1959), Olympic Ski Patrol (1960), and Arapahoe Basin Ski Patrol (1977). In 1958, Axley and Kenneth Wright were awarded the NSPS Purple Star and ARC Award of Merit for saving a life. At the 1960 Winter Olympics, Axley was the director of the flag ceremony at the opening and closing ceremonies. As NSPS Front Range director, Axley was responsible for the formation of ski patrols at Breckenridge, Squaw Pass, Ski Idlewild, Lake Eldora, Hidden Valley, Loveland Valley, Fun Valley, Geneva Basin, Meadow Mountain, and Vail.

**MAHONEY AND STEVENS, C. 1990S.** This photograph shows Bill Mahoney and Johnnie Stevens. Stevens is a native of Colorado who has spent most of his life in the majestic San Juan mountains of southwest Colorado. Skiing became a large part of his life at an early age. He worked his way up from the bottom at Telluride, starting in construction on the mountain, cutting trails, and running snowcat tours before moving on to the ski patrol, quickly becoming ski patrol director. He proved his worth by rapidly working up the ladder of company management, working as assistant mountain manager, mountain manager, and vice president in mountain operations, skier services, and ski operations, and then as senior vice president of mountain operations and environmental affairs. He completed his career as chief operating officer. Bill Mahoney moved to Telluride at age four. In 1972, Telluride Ski Resort founder Joseph Zoline named him the mountain manager, and he thoughtfully planned and sustained the development of Telluride.

# 4
# Pre–World War II Resorts

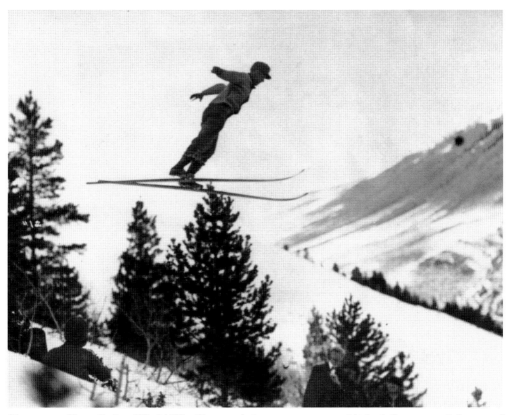

**Howelsen Hill.** Before World War II, several ski resorts were established. Some stood the test of time, and some have since closed. Howelsen Hill has the distinction of being one of the country's oldest ski areas in continuous use, located in Steamboat Springs. It was founded in 1914 by Carl Howelsen, a Norwegian immigrant who helped popularize ski jumping and cross-country skiing. In this chapter, we will also look at Loveland, Berthoud Pass, and Wolf Creek ski areas.

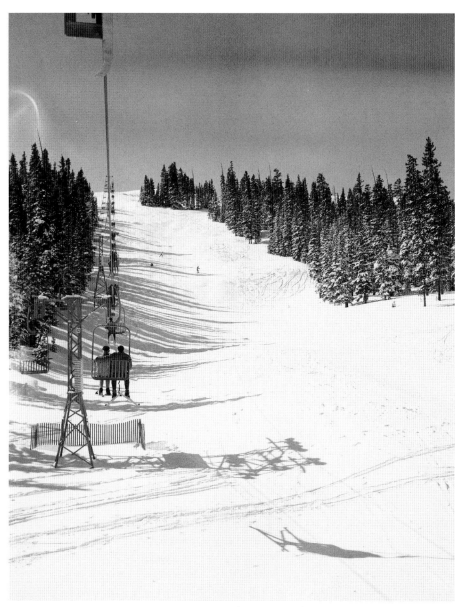

**CHAIRLIFT AT LOVELAND, 1963–1964.** Loveland Ski Area is Colorado's longest operating, privately owned ski area, first opening its slopes to skiers in 1936 when J.C. Blickensderfer installed a tow at what is now called Loveland Basin. The following season, Al Bennett continued the operations by using a Model T engine to power the lift. Starting in 1955, Chester "Chet" R. Upham Jr., Al Bennett, Robert Murri, Bill Bolin, and Pricilla Barnard purchased Loveland. As president, Upham's vision, values, innovations, vigilant investment, and good business sense created this iconic, mid-sized ski area that offers an unparalleled, affordable, and classic family-oriented mountain experience. Peter Seibert, the future founder of Vail and a 10th Mountain Division veteran, was named general manager in 1955. By the late 1950s to 1960s, construction of the Eisenhower Tunnel began, which runs directly below the base of Chair 4.

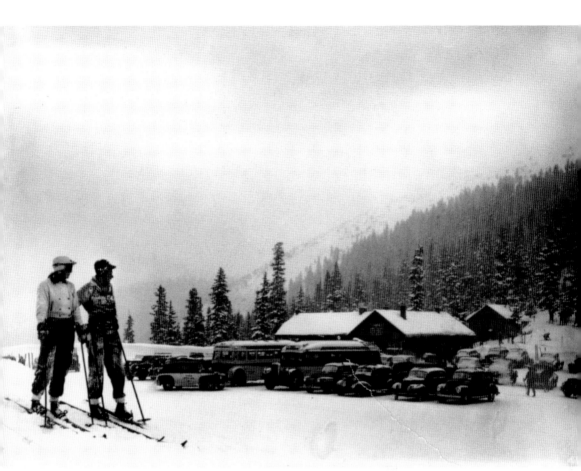

**BERTHOUD PARKING LOT, FEBRUARY 1942.** Beginning in 1937, the first lift at Berthoud Pass Ski Area was powered by a Ford engine and run by volunteers on weekends. Many maintain that Berthoud Pass was one of Colorado's first ski areas. Near Denver, Berthoud enjoyed continued success from the outset following World War II, catering to both expert skiers and families. In addition to building the first double chair, the area was also the first to use a discounted and transferable season pass, as well as one of the first in Colorado to allow snowboarding. Additionally, Berthoud Pass was home to the Slippers-N-Sliders ski club and welcomed Colorado's first Black ski patrollers, Bryce Parks and Floyd Jackson. Financial troubles required the area to liquidate in the 1990s and close as a ski area in 2001. Berthoud Pass is now considered one of Colorado's abandoned ski areas. Due to challenging terrain and great snow, the pass is a destination for backcountry skiers and is still enjoyed by many snow sports enthusiasts. (Photograph by Jay Higgins.)

ELLIOTT AT WOLF CREEK, 1936. Wolf Creek Ski Area has a long history in southwest Colorado, located on Wolf Creek Pass. During the 1930s, people were refining the mountains of Colorado by building highways and mountain passes. The construction project between San Luis and Pagosa Springs was named Wolf Creek Pass. By 1938, a rope tow powered by an old Chevy truck was installed near the summit of Wolf Creek Pass. The ski area officially opened in 1939 and lift tickets cost $1 per day. Shortly afterward, a warming shelter and dirt road were constructed. The ski operation on Wolf Creek Pass underwent drastic changes in 1955. Under the control of the Wolf Creek Development Corporation, the ski area moved to its present location across the road. From 1936 to 1944, Charles Elliott was the driving force behind the growth and interest in skiing at Wolf Creek. He helped reestablish the ski patrol in the area.

MONARCH PASS, C. 1936. People have been skiing the mountains surrounding the valley of Monarch Mountain since 1914. Monarch's first unofficial winter season was in 1936, when James Kane and the Salida Winter Sports Club brought a Chevy truck engine up Monarch Pass highway. Other skiers instrumental in the initial opening of the area were Thor Groswold, Sven Wiik, and Charlie Vail. By 1939, the club applied to the US Forest Service for a permit to cut trails, construct a lodge, and erect a lift. The first run cut at Monarch was Gunbarrel, an expert trail with a 30 percent slope. During the first official ski season of 1939–1940, season passes cost $1. Rope tow revenues netted over $50, with 25¢ day tickets. Ownership of the resort changed multiple times, with each change resulting in additional lifts, more terrain, and a base lodge. Stability returned to Monarch in the 1990s after a turbulent decade throughout the 1980s when the area filed for bankruptcy. In 2006, the Mirkwood Basin opened to skiers and riders willing to hike.

BURGE AT COOPER, C. 1940S. This photograph shows Col. Paul Burge at Cooper Hill. Although this Colorado ski area opened during World War II, it is still worth noting here. In 1942, the US Army selected a training site near an isolated railroad stop in Pando, Colorado, known as Camp Hale for training the ski troopers of the 10th Mountain Division. Nearby Ski Cooper (then known as Cooper Hill) was used as a six-month-long ski training site, which included the use of its infamous T-bar. Following the war, Ski Cooper opened to the public for the enjoyment of the local area residents, as one of the oldest ski resorts in Colorado. After World War II, the T-bar became Army surplus property, as did the equipment of the 10th Mountain Division. The Lake County Recreational Board expressed interest in taking ownership of the T-bar to expand recreational opportunities for its residents. The Forest Service provided Lake County with a 99-year lease for the Cooper property, and it took ownership of the T-bar.

# 5

# 10TH MOUNTAIN DIVISION AND COLORADO SKIING

**10TH MOUNTAIN DIVISION, C. 1940S.** After World War II, many 10th Mountain Division veterans returned to Colorado. They founded or were affiliated with some 62-plus ski resorts across the United States. In Colorado, these include Vail, Aspen, Arapahoe Basin, Winter Park, Loveland, and more. Veterans of this elite mountain troop also helped with ski schools, advancing equipment, and creating the 10th Mountain Division Hut System.

**CHASE AND CHILDREN, C. 1960.** Veterans of the 10th Mountain Division came back to Colorado and were instrumental in building ski schools, which are one of the most important organizations for learning how to ski and keeping the slopes safe. Veterans Merrill Hastings, Larry Jump, Clif Taylor, Gordy Wren, Rudi Schnackenberg, and more founded or were involved with ski schools after the war. Two skiers of note, Friedl Pfeifer and John Litchfield, returned to Aspen in 1945. Pfeifer, along with Litchfield and Percy Rideout, started the Aspen Ski School, where Pfeifer was named director and Litchfield co-director. Curt Chase was a survival training instructor for the 10th Mountain Division during World War II. In 1946, he moved to Aspen and immediately organized, trained, and directed the Aspen Ski Patrol. He also became an apprentice ski instructor for the Aspen Ski School. From 1963 to 1980, he served as the director of the Aspen Ski School and Snowmass Ski School for five years. As a ski instructor, he helped in the development of the "basic turn" approach to ski instruction, now known as the American Ski Technique.

**HASTINGS AND GROUP.** Merrill G. Hastings Jr. served in the 10th Mountain Division (Company H, 86th Mountain Infantry), and after returning to the United States as a decorated hero, he joined the construction crew building Arapahoe Basin. Hastings was a Berthoud Pass Ski School director and a national ski patrolman, starting the ski association that evolved into the Rocky Mountain Division of the Professional Ski Instructors Association (PSIA). He started *Rocky Mountain Skiing* magazine in 1948—which became *Skiing* magazine—and successfully ran it for 16 years. In March 1998, Hastings was named to the Ski Industry Hall of Fame by *Skiing*. Below, Hastings is at left with the Berthoud Pass Ski School.

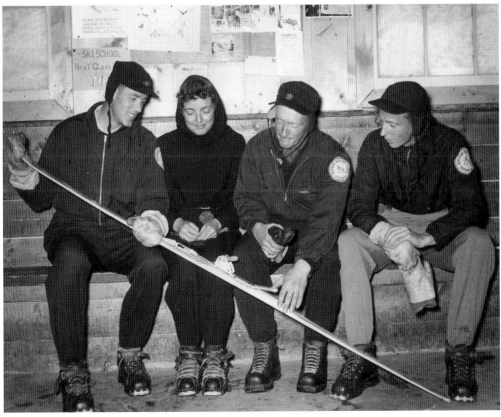

SKIING IN COLORADO

**EQUIPPED SOLDIERS, C. 1940S.** The 10th Mountain Division was at the forefront of new techniques in winter survival, skiing, and equipment, including all-terrain ski bindings and metal edges on skis. After the war, the Army sold tens of thousands of surplus skis, bindings, boots, and poles to the public at rock-bottom prices. This, plus the thousands of 10th Mountain Division veterans working in the ski industry as teachers, patrolmen, managers, and more, introduced the American public to skiing and revolutionized skiing and outdoor recreation in Colorado. The image below shows 10th Mountain Division soldier Richard "Dick" Over at Camp Hale.

TROOPERS AT CAMP, C. 1940S. Many veterans innovated with the surplus equipment and improved upon gear and clothing in the years after the war. Gerald "Gerry" Cunningham founded Gerry in Ward, Colorado, in 1946, and its first retail stores opened in Boulder in 1958. Most notably, Gerry developed the triangular carabiner, the drawstring cord lock, tents that were used in the first successful Everest expedition, and—for the 1964 Winter Olympics—the Olympic committee wore Gerry down-filled ski coats. In 1971, Cunningham resigned from the company, expressing that it was too big and no fun anymore. In addition, many 10th Mountain Division veterans worked with Howard Head to help him develop skis, as they were considered skiing experts. Lastly, William Bowerman co-founded the Nike corporation. He served with Company G of the 86th Mountain Infantry.

**FREDRIC "FRITZ" BENEDICT.** Backcountry skiers have long relied on mountain huts to provide a haven, the most famous being the Haute Route between Chamonix, France, and Zermatt, Switzerland. The Fern Lake Lodge in Rocky Mountain National Park was used as early as 1916. Before serving as a 10th Mountain Division ski trooper during World War II, Fritz Benedict had envisioned a hut system based on New Hampshire's 100-year-old hut system. After the war, he and a group of friends set their sights on creating the perfect ski touring experience between Vail and Aspen. Benedict enlisted the aid of former US secretary of defense Robert McNamara, who helped convince the US Forest Service of the project's potential and assisted with funding. In 1982, McNamara Hut and Margy's Hut (McNamara's wife) became the first 10th Mountain huts built. Today, the 10th Mountain Division Hut Association manages the backcountry huts connected by 350 miles of trails throughout Colorado, the largest backcountry hut system in the United States. Another veteran, Hugh Evans, also helped develop and direct the hut system.

# 6
# COLORADO SKI RESORTS POST–WORLD WAR II

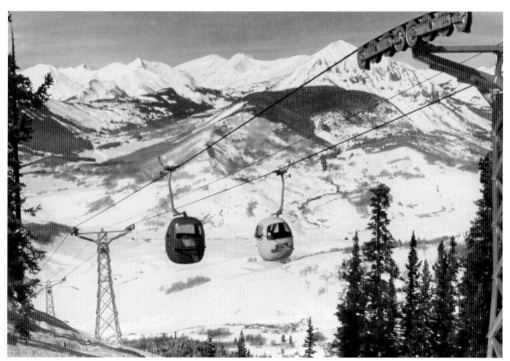

**CRESTED BUTTE GONDOLA, 1963.** After World War II, Colorado saw a boom in ski resorts. With the influence of 10th Mountain Division veterans and skiing becoming more accessible, places like Arapahoe Basin, Aspen, Vail Mountain, Steamboat Ski Resort, and Eldora opened throughout the mid-1940s to the 1960s. Purgatory, Crested Butte, Sunlight, and more also opened in the 1960s. It was not until the 1970s that places like Telluride Ski Resort and Copper Mountain opened.

ARAPAHOE BASIN. Arapahoe Basin, also known as A-Basin, opened in December of 1946 and was the first post–World War II ski area to open in Colorado and the oldest ski area in Summit County. It opened with a tow rope that cost $1.25. For the 1947–1948 season, a single chair was installed, which used metal parts. This was rare and was the first metal chair installed in postwar times.

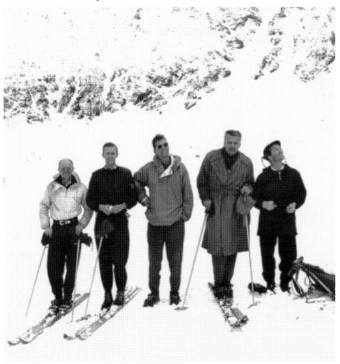

A-BASIN FOUNDERS, C. 1940S. The vision for A-Basin began with its founders, shown here from left to right: Max Dercum, Larry Jump, Thor Groswold, Frederick Schauffler, and Dick Durrance. Jump was a 10th Mountain Division veteran who relied on help from other veterans to build A-Basin, including Merrill Hastings, Wilfred Davis, and Earl Clark. Hastings helped with initial construction and Davis with slope layout, avalanche control, and ski area safety. Clark joined the ski patrol.

**FRIEDL PFEIFER, C. 1940S.** The foundations for the Aspen Skiing Company were laid in the 1930s, but World War II halted these plans. Aspen started operations on December 14, 1946, as the first ski area venture of the Aspen Skiing Company founded by Walter Paepcke. Prior to 1946, the mountain had been the site of skiing using a crude boat lift, and jeep trails up the back side. Many of the first employees were veterans of the 10th Mountain Division, which had trained at Camp Hale, including Friedl Pfeifer and Pete Seibert, who co-founded Vail. Pfeifer operated the ski school. Veteran Robert Heron also helped advance Aspen's lifts. Heron, a Colorado native, was an engineer who designed passenger tramways for the military. These tramways served the 10th Mountain Division. In 1945, he organized the Heron Engineering Company and was president until 1969. His company won recognition for installing the famous No. 1 chairlift in Aspen and constructing the second section of the sundeck.

SKIING IN COLORADO

**DOWNTOWN BRECKENRIDGE, C. 1960s.** The concept of building a ski resort in Breckenridge began during the late 1950s when Bill Rounds of the Porter and Rounds Lumber Company became interested in bringing skiing to the valley. The Peak 8 Ski Area opened on December 16, 1961, with one Heron double chair and one short learner's T-bar. Ticket prices were $4 for an adult and $2.50 for children.

**SIGURD ROCKNE AND BERGE, 1965.** With Round's help, Trygve Berge helped design the ski area of Breckenridge and lay out the trail system. In 1961, Berge founded the ski school with Sigurd Rockne. Berge and Rockne ran Breckenridge for the first 10 years. As co-founders of the resort, they set the tone for the new area and made sure it was a fun place to be.

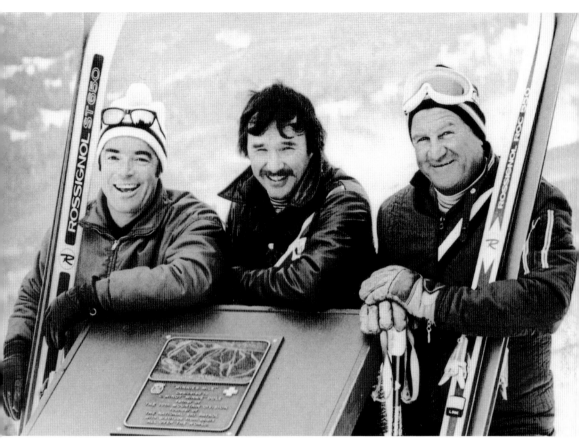

**VAIL DEVELOPERS, C. 1970S.** This photograph shows Pete Seibert, Bob Parker, and Bill Brown. In 1957, Seibert, a 10th Mountain Division veteran, met fellow ski patroller Earl Eaton, who introduced him to the unnamed mountain that would become Vail. Seibert was convinced it was the perfect place and bought the land. Others invested, construction began, trails were cut, lifts erected, and the resort opened for the first time on December 15, 1962. Vail's history is inseparable from the 10th Mountain Division's history because of Seibert's reliance on fellow veterans like Jack Tweedy, Ben Duke, Bob Parker, and Bill "Sarge" Brown, whom he met while training and fighting during World War II. Fellow veteran Bob Parker joined Seibert and Vail as an unpaid consultant in 1960 and developed strategies for promoting national attention on a shoestring budget. Parker led the effort to bring international ski racing stars to Vail, and by 1967, the resort was well positioned to become an early venue for World Cup races. Sarge Brown became the mountain manager of Vail and created an international reputation for his mountain management skills.

**SKIERS AT VAIL, C. 1960S.** As the town and resort continued to grow, a new breed of ski pioneers descended upon the valley, looking to lend their talents to the success of the fledgling resort. These new arrivals quickly translated their big personalities into significant growth and improvement, not to mention the character of the community.

**GRAMSHAMMERS SKIING VAIL, C. 1960S.** Pepi Gramshammer, a successful Austrian ski racer, was recruited to Vail to become the public face of the resort. He met and married Sheika, who was working as a model in New York and Las Vegas, and though they had no experience in hotel or sport shop operations, they opened Gastof Gramshammer and Pepi Sports on Bridge Street. Pepi and Sheika Gramshammer became the unofficial hosts of Vail Village.

**EVA CSEH, C. 1962–1969.** Eva Cseh Distel was the wife of Gabor Cseh, one of the founders of Eldora and one of the first to explore this area in the 1950s, in hopes of making it a ski area. The idea of building a ski resort at Lake Eldora, just west of Nederland, became a reality in 1961 when Gabor Cseh, George Sweeney, Frank Ashley, and Donald Robertson approached the US Forest Service. The over 400 acres purchased consisted of the base area lodge and the parking lot. By 1962, construction was underway for the Shelf Road connecting Nederland to the ski area. Eldora started operations on January 5, 1963. Along with the access road, two T-bars ran the first season. Frank Ashley, another founder, was general manager of the Aspen Ski Corporation before he became active with Eldora's development.

**JAMES TEMPLE, C. 1950S.** Steamboat Resort is a major ski area in northwestern Colorado, in Steamboat Springs. Once Carl Howelsen had established skiing as a sport at Howelsen Hill, skiers began looking toward Storm Mountain. During the late 1950s, James Temple organized ski trips and summer rides to the summit to explore routes for trails and lifts. To promote his new ski area, he got permission to use the phrase "champagne powder," coined by rancher Joe McElroy. On January 12, 1963, Steamboat Resort launched as Storm Mountain with one lift and a warming hut at the base. The mountain was renamed Mt. Werner in 1964 after Buddy Werner, a famous local Olympic skier who sadly died in an avalanche. The town is informally known as "Ski Town USA" since it has produced more ski team athletes than any other ski area in the nation. Steamboat has produced Olympians John Steele, Crosby Perry-Smith, Buddy Werner, Skeeter Werner Walker, Loris Werner, Katy Rudolph-Wyatt, Keith and Paul Wegeman, Billy Kidd, Jim Barrows, Hank Kashiwa, Johnny Spillane, Todd Lodwick, Shannon Dunn-Downing, and more.

**PURGATORY.** Purgatory Ski Area opened on December 4, 1965, providing the town of Durango with a new ski area. The resort was the idea of Chet Anderson, who worked for the Forest Service, and Ray Duncan, whose family was in the oil business; he himself was inimitable. Both loved skiing and wanted to make the sport more accessible to the Durango area. Dolph Kuss and Paul Folwell were also key developers. The name stems from the Spanish Escalante expedition during the 1700s, when one of the members fell into the swiftly flowing Animas River near the site of the ski area and perished in its waters. Group members named the river El Rio de Las Animas Perdidas en Purgatorio, "the River of Lost Souls in Purgatory."

POWDERHORN MOUNTAIN RESORT. Skiing on the Grand Mesa began in the 1930s with a rope tow and reappeared at Mesa Creek (Old Powderhorn) shortly after World War II. Initial survey tours of the Powderhorn Mountain Resort site began in 1958, and both members of the Grand Mesa Ski Club and US Forest Service recommended the development of a ski area on the site. On December 5, 1966, about 1,500 people witnessed Colorado governor John Love cut the ribbon officially opening Powderhorn Ski Area. A Riblet double chair spun on opening day. Gordy Wren, who conducted an initial evaluation of the area and recommended it for development, was a member of the famed 10th Mountain Division and the 1948 US Olympic ski jumping team.

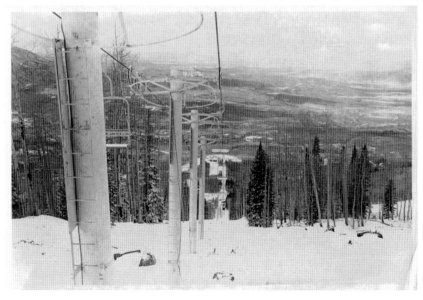

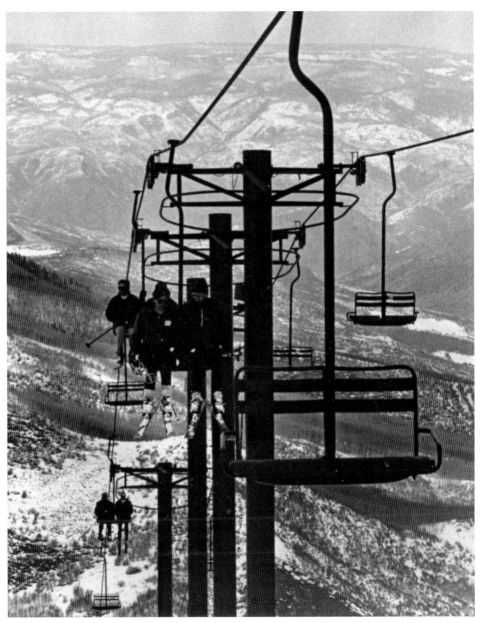

**SUNLIGHT MOUNTAIN CHAIRLIFT, C. 1960S.** Sunlight Mountain Resort was the dream of John Higgs, a Chicago native. His site selection for a new ski area was at the former location of Holiday Hills, an abandoned ski area just outside of Glenwood Springs. The Sunlight Ranch Company opened the ski area on December 16, 1966, with a handful of trails expanding over 15 miles and skier days totaling 15,000. Lift tickets cost $5.50 during the first season. The area operated one Riblet double chair, servicing the entire mountain. In the 1980s, chairlift improvements were made, doubling Sunlight's uphill capacity and improving access to the entire mountain. In 1985, Tom Jankovsky became general manager for Sunlight. For 25 years, he focused on the skier experience and marketing the area as a friendly community.

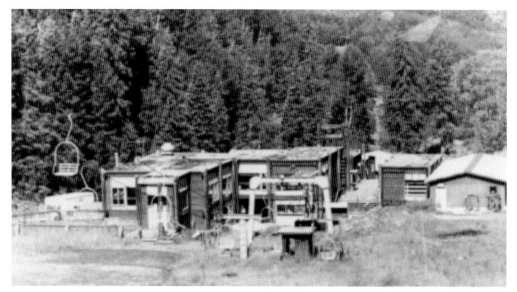

**DAY LODGE CONSTRUCTED, 1972.** The town of Telluride was founded in 1878 under the name of Columbia but was renamed due to confusion. Some believe it is derived from "To-hell-you-ride" because of its remote location. Others believe the name stems from the metal Tellurium, as Telluride was an early mining town. By the 1970s, a California resident found an opportunity to develop a ski area, and Telluride Ski Resort opened in 1972 with five chairlifts and a day lodge. (Courtesy of Ron Allred.)

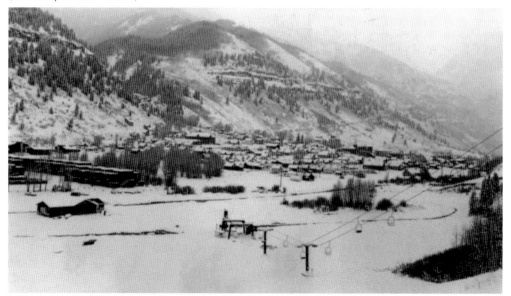

**COONSKIN LIFT CONSTRUCTION, 1975.** In 1978, following the financial collapse of Telluride, Ron Allred started an effort to create a new economy in Telluride based on a year-round mountain resort community. He headed a company that built a new ski mountain and Mountain Village, as well as a new golf course and airport. Thanks to Allred, Telluride has remained a world-class resort. (Courtesy of Ron Allred.)

**COPPER MOUNTAIN, C. 1970S.** Before Anglo-American settlement, Ute and Arapaho used the forests in and around Copper Mountain for fishing and hunting. During the 19th century, mining took over the region that is now Summit County. The copper in this mountain gave the peak its name. In 1971, Chuck Lewis purchased 280 acres at the base of Copper Mountain with a vision for a ski resort. He began clearing trails that same year.

**MAIN BASE HOUSE, C. 1970S.** Copper Mountain opened in 1972 with 26 trails; lifts F, G, B, E, and C; and two buildings: the Center and Solitude. From 1997 to 2009, it was owned and operated by Intrawest, which launched a multi-year, $500 million renaissance on Copper Mountain. Copper hosted the World Cup in 1976 with four Alpine ski races. In 2009, Powdr acquired Copper.

SKIING IN COLORADO

BEAVER CREEK AT MCCOYS, 1989. The idea of building a new ski resort in the Beaver and McCoy Creek areas came about in 1956 when Earl Eaton and John Burke discussed future possibilities. At this time, Vail was about five years from opening. Talks for a ski area on this site became more plausible when Denver won the bid for the 1976 Winter Olympics and it was decided that Beaver Creek would hold the Alpine events, prompting Vail Associates to file for a new ski area permit with the US Forest Service. However, Denver voters rejected the 1976 bid, and plans to build the resort collapsed. Obstacles delayed resort completion, but on December 15, 1980, Beaver Creek finally opened. After such an aggressive fight to build Beaver Creek, the ski resort saw much growth throughout the 1980s, including opening a new bowl and installing new high-speed lift technology. (Photograph by David Lokey.)

ARROWHEAD CABIN, C. 1980S. Beaver Creek encompasses three villages: the main Beaver Creek village, Bachelor Gulch, and Arrowhead. The resort is known for its upscale family-oriented accommodations, terrain (including the famous Birds of Prey runs), and exceptional golf course. In 1977, Vail Associates was sold to Harry Bass and Goliad Oil & Gas. The 1980s ushered in a new era for the Vail Valley with the opening of Beaver Creek in 1980. The name "Vail Valley" was coined to market Vail and Beaver Creek as one destination, with interchangeable lift tickets. The Bass brothers explored and purchased Nottingham Ranch and started building. George Gillett Jr.'s purchase of Vail and Beaver Creek in 1985 brought another new era for the Colorado ski industry. His main goal was to create a great family experience and put a smile on the faces of guests.

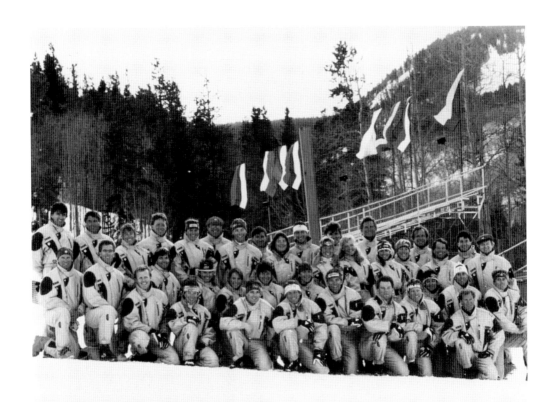

WORLD CHAMPIONSHIP TEAM, 1989. Beaver Creek hosted the 1989 FIS Alpine world ski championships along with Vail, its sister resort. Bill Brown, a 10th Mountain Division veteran, and the mountain manager at the time, was instrumental in organizing and running the 1989 championships. Beaver Creek and Vail also hosted the 1999 and 2015 championships, and for the last several years, Beaver Creek has hosted the Birds of Prey World Cup downhill ski race.

PRESIDENT FORD, C. 1970S–1980S. Pres. Gerald Ford is known as the first skiing president. After retiring from politics, he helped put Vail and Beaver Creek on the map. One of the many contributions Ford made is his role in bringing three world championships to the Vail Valley. It was a major coup for Colorado to promote ski racing. Ford is wearing a 1976 Denver Olympic bid hat in this photograph.

# 7

# ABANDONED AND LOST RESORTS

**MESA CREEK, 1940s–1950s.** Colorado has seen 140-plus ski resorts close their doors or become abandoned over the years. These areas are referred to as "lost resorts." One of them was Mesa Creek, located near Powderhorn Ski Area on the Grand Mesa, and called "Old Powderhorn" by many locals. It was opened in the 1940s by the Grand Junction Ski Club. Membership at the time cost about $1. Mesa Creek closed in 1966 once the development of Powderhorn began.

RED MOUNTAIN, C. 1940S–1950S. This ski area dates to 1937, when J.E. Sayre donated a part of Red Mountain, near Glenwood Springs, to be used for skiing. It is rumored, however, that the area was used for skiing as far back as the 1880s by locals. In 1940, the Civilian Conservation Corps helped clear ski runs and a lift line. The lift was installed in 1941 and the resort opened in the fall. Red Mountain's slopes, served by one of the nation's longest chairlifts, were considered among the best in Colorado in the 1940s. The area opened to the public in 1942, but World War II limited its use. In 1943, it went to a weekend-only operating schedule, with prices of $1 for adults and 60¢ for children. The area boomed in the late 1950s once a new lift was installed. Money woes forced Red Mountain to close in 1959 as other ski resorts with better snowfall were developed.

**CLIMAX TOW, C. 1940s.** Climax Ski Area was started mainly for the employees of the Climax Molybdenum Mine. It dated to 1934 and featured the first night skiing in Colorado. It had one T-bar and was located at the top of Fremont Pass, between Copper Mountain and Leadville. The area got great snow and was accessed by purchasing a $10 pass. The area closed in the 1960s.

**SKI LESSON AT CLIMAX, C. 1940s–1950s.** During the 1940s, Jack Gorsuch worked at the Climax mine and helped form the Continental Ski Club. The club constructed a rope tow, cut runs, and installed lighting for night skiing, then ran the ski area. Much of the equipment, from light bulbs to the diesel engine that powered the tow, found its way to the slopes from the mine. Climax drew around 500 skiers on weekends, including 10th Mountain Division soldiers from Camp Hale.

**GLEN COVE, C. 1930S–1940S.** The Glen Cove ski area was located off the Pikes Peak highway outside of Colorado Springs and was active from 1924 through the 1940s. Ski jumps began in the mid-1920s. Both the Pikes Peak and Silver Spruce Ski Clubs were popular in this area during this time, bringing skiers to Glen Cove.

**LAWRIE AND BOB POTTER, 1936.** Don Lawrie added the state's first rope tow at Glen Cove in 1936. It was powered by a Whippet car engine. During World War II, he arranged for the Glen Cove course to be opened to military personnel from Camp Carson. The area closed in the 1940s. (Photograph by Clarence G. Coil.)

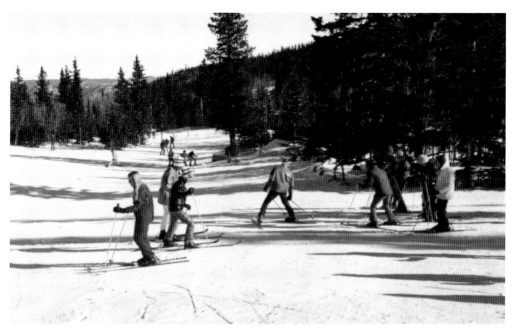

**PIKES PEAK, JANUARY 1973.** Starting in 1939, Pikes Peak was a major ski area in the Colorado Springs area. In 1954, the slope at Elk Park claimed the skiers who formerly used Glen Cove, a mile uphill. During the early 1980s, the area added a $700,000 triple chair made by Poma. The chair served new terrain above the timberline, but the snow was wind-blown and often sparse at those elevations. After the lift was installed, the area was unable to pay taxes or Poma for the lift. The first year, Poma bailed the area out by lending it money. Pikes Peak went bankrupt in 1984. It has been closed ever since.

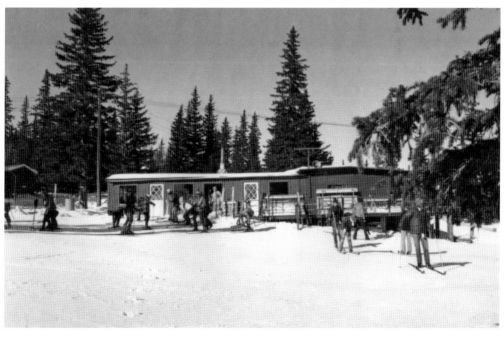

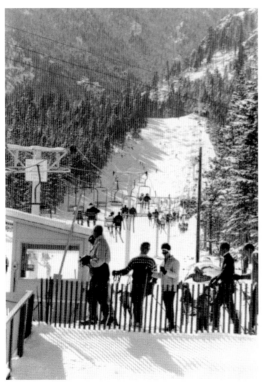

**BROADMOOR CHAIRLIFT, C. 1959–1960S.** Ski Broadmoor was built and operated by the Broadmoor Hotel in Colorado Springs. It first opened in November 1959. The hotel sold the resort to the City of Colorado Springs in 1986, and the city ran the resort for two seasons until Vail bought it in 1988. It was closed in 1991. The extremely low elevations at Broadmoor meant that it had to rely entirely on its snowmaking capabilities.

**KNOWLTON MAKING SNOW, C. 1962.** Broadmoor's snowmaking equipment was bought from the defunct Magic Mountain. Its slopes were mostly beginner-friendly. There was a double Riblet chairlift and tow, with a capacity of 600 people per hour. Adult tickets were $11. Steve Knowlton, the founder of Colorado Ski Country USA, helped with planning the construction of the area and initiated junior ski and night ski instruction programs.

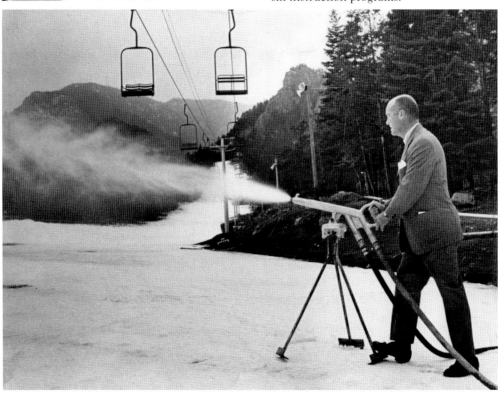

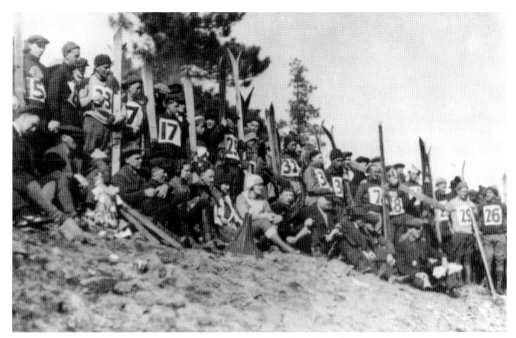

**GENESEE MOUNTAIN SKI JUMP, 1925.** These photographs show ski jumpers at Genesee Mountain in Jefferson County. This was a stop on the national ski jumping circuit from 1921 to 1927. While it was close to major cities, snow tends to be unpredictable at that elevation. During the mid-1950s, the University of Denver used the area for ski jump training. The site was considered for the 1976 Winter Olympics, which was defeated by Colorado voters in 1972. Today, condominiums crowd the lower portion of the jumping areas.

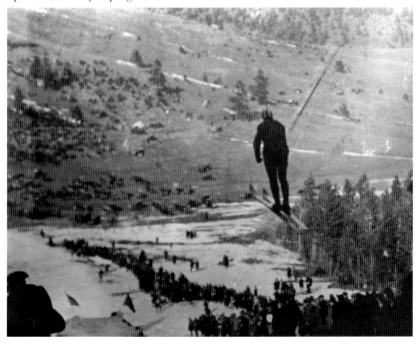

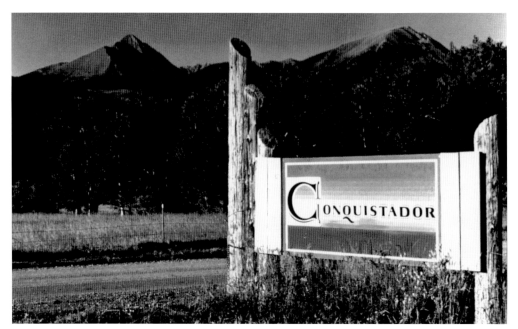

**CONQUISTADOR SKI AREA, C. 1980S.** Conquistador, founded by Dick Milstein in the northern Sangre de Cristo Mountains near the town of Westcliffe, opened in 1978. Two pony lifts with a scant 85-foot drop served for five years. Two Doppelmayr chairlifts were added in 1982 in a major expansion, accompanied by a major default on loans. The Small Business Administration foreclosed on the property and the government ran the resort until it closed in 1988. The resort reopened under the name Mountain Cliffe for the 1992–1993 season and was bought by Mund Shaikly and Ray McEnhill. Snow was lacking early in the 1992 season, and a large windstorm stripped the slopes of snow. The area closed early, citing poor conditions. This was its final season, and lifts were removed in 1996.

# 8
# Early Adaptive Pioneers

ADAPTIVE INSTRUCTION. Adaptive skiing allows people with disabilities to ski using specialized equipment, which grew from a recreational pursuit into a competitive sport, with 17 skiers participating in the first championships in Austria in 1948. Colorado led the way in adaptive snow sports since 10th Mountain Division veteran Jim Winthers taught amputee veteran friends how to ski. With the support of other veterans, Winthers founded Disabled Sports USA in 1967.

OUTRIGGERS, C. 1950S–1960S. Elizabell "Willie" Williams came to Colorado to work as a nurse for the Children's Hospital in Denver. Her love for children led to her coordinating a ski program for young patients with limb amputations. The first class for 17 boys was held at Arapahoe Basin in January 1968, with the help of Willy Schaeffler and ski school head Ed Lucks. The program was called the Three Track Ski Club. Outriggers, shown here, provide balance and stability for adaptive skiers, leaving their own tracks in the snow, hence the name. In 1970, the program moved to Winter Park, where Hal O'Leary took over. This was the beginning of the internationally acclaimed National Sports Center for the Disabled. Williams and O'Leary developed and trained skiers who eventually became world champions. Without the early efforts by these adaptive skiing innovators, many Paralympic athletes would not have had the foundations to achieve success.

**THE LUCKSES, C. 1980S–1990S.** Through Ed Lucks's willingness to teach, his pioneering techniques, and his experimentation with equipment, he has brought the freedom and confidence of skiing to thousands of people, always stressing abilities, not disabilities. Lucks began teaching skiing at Arapahoe Basin in 1964, and it was here that he began his lifelong mission to share the sport he loved with disabled people. Two years later, when Arapahoe Basin was hosting Vietnam veterans and a group from the Children's Hospital of Denver, the ski school director asked for volunteer instructors. At a time when adaptive skiing was just gaining acceptance, no one volunteered. When Ed's wife, Evie, heard he had not volunteered to help, she quickly changed his mind, and he found his calling.

LUCKS AND STUDENT. In 1969, Lucks took a job at Crossroads Drugs in Aspen and continued to work as an instructor at Buttermilk Mountain, and then moved to Snowmass. Aspen Skiing Corporation decided to utilize his talents. Thus began over 26 years of teaching people with disabilities to ski at Snowmass. Lucks practiced skiing on one leg and skied blindfolded, to see what methods and techniques would work best for his students. If he did not like the way a piece of adaptive ski equipment worked, he would spend countless hours modifying it to meet his students' needs. At a time when there was not much equipment for adaptive skiing, Lucks's home quickly became an experimental factory for ski gear as he went to work producing primitive outriggers or whatever equipment was needed to help his students learn. Many of his pioneering designs are still in use today. He developed the bend found in many outriggers, called the Ed Lucks Bend in his honor.

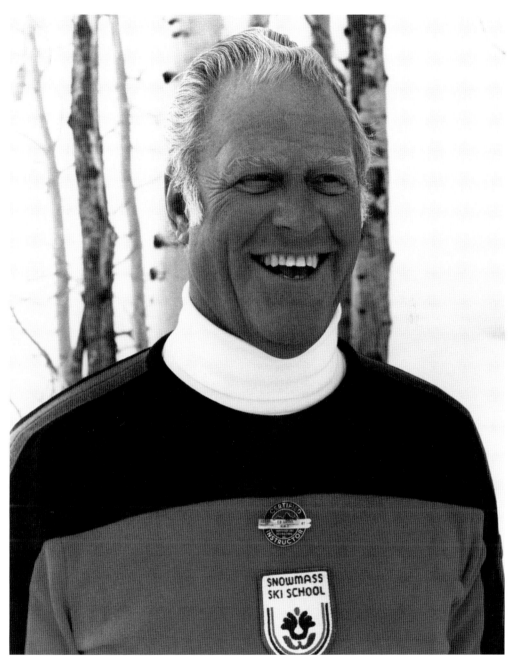

**SNOWMASS INSTRUCTOR LUCKS, C. 1970S.** Ed Lucks has selflessly shared his knowledge and teaching with instructors and volunteers throughout the world. Through his years of hard work, he has taught many to ski and helped lay the foundations for both the US Disabled Ski Team and Challenge Aspen. Lucks has touched the lives of many students and helped spread the joy of skiing. To honor him for his many years of service, Snowmass Village declared February 16, 1991, Ed Lucks Day. His contributions to the legacy of Colorado skiing go well beyond the slopes. Through his passion for skiing and desire to share it, Lucks gave his students something more than a ski lesson.

**NEVINS AND FAMILY.** Hugh Nevins, a retired US Air Force colonel, has touched and enriched the lives of thousands of blind people since 1975. He developed the nonprofit Colorado Ski School for the Blind that year and developed the vital blind skiing technique that has sustained the program ever since. His skiers ranged in age from 4 to 72. Nevins started with three children and by 1985, enrollment had jumped to 478. By 1987, over 1,000 people had participated annually. Students came from all over the country to learn at Vail, Beaver Creek, Loveland, and Monarch. Nevins makes believers out of his students, telling them they can indeed do anything they set their hearts on. When he was 79, he was still the ultimate unpaid volunteer but had the support of many other tireless volunteers to make the program successful.

HUGH J. NEVINS. In addition to Nevins's impact on teaching the blind to ski, he also touted an impressive service history and a connection to the 10th Mountain Division. During his military career, which started with the cavalry, then the Air Force, Nevins was selected as an Air Force project officer to flight-test air missions in support of the 10th Mountain Division because he not only could fly airplanes, but could also fly combat gliders and ski. Nevins air-supplied trooper elements to the 10th Mountain Division in combat sites of 10,000- to 13,000-foot elevations west of Leadville under extremely hazardous conditions in 1943. His risky operations proved that Operation Sea Eagle, the airborne invasion of Norway using gliders at less than 4,000 feet by the 10th Mountain Division, was feasible. Nevins eventually became the world's most decorated combat glider pilot of World War II.

**BLIND SKIING.** Another individual who dedicated countless hours to helping adaptive skiers is Sandy Treat. During World War II, Treat volunteered for the 10th Mountain Division. He returned to Colorado in 1986 and became one of the most dominant Masters skiers—skiing well into his 80s. In 2009, he had a serious crash and lost the function of one of his eyes. Despite this ending his racing career, his commitment to Colorado skiing endured. He put his time and effort into Foresight Ski Guides, out of Vail, to help visually impaired skiers and the Vail Veterans Program help bring injured soldiers to Colorado. In blind skiing, a sighted skier accompanies the blind skier and calls out instructions.

**BENEDICK AT POWDERHORN, C. 1980S.** Colorado has a long history of supporting and producing Paralympians. Trygve Myhren was instrumental in making Paralympic skiing the first adaptive sport to be fully integrated into the Olympic program. In 1995, he helped launch SkiTAM, a fundraiser program for the US Disabled Ski Team. Through his leadership, he helped secure the future of competitive adaptive skiing. In addition, Jack Benedick remains an inspiration to adaptive snow sports. In 1969, Benedick lost both his legs in combat in Vietnam. He was introduced to skiing at Arapahoe Basin while doing rehab at the Fitsimmons Army Medical Center in Denver. He turned to skiing as a form of rehabilitation. He won numerous medals in the Paralympics, after which he became adaptive sports' most influential advocate. He was named to the US Adaptive Ski Team in 1979. In his first Paralympics in 1980, he scored three top-five finishes and won silver in 1984.

STARTING GATE, C. 1990s–2002. Sarah Will, shown here, moved to Aspen in 1987, but after only three months suffered a tragic ski accident that left her paralyzed from the waist down. Highly motivated, Will took on the challenge of rehabilitation. She read the book *Bold Tracks* by Hal O'Leary, head of the National Sports Center for the Disabled in Winter Park. One year later, she was making her first turns on a monoski. She moved back to Colorado in 1992 to train at Winter Park, started competing, and later that year was named to the US Disabled Ski Team. She later moved to Vail where, with teammate Chris Waddell, she founded the Vail Monoski Camp. During her competitive career, she represented the United States at the Paralympics in 1992, 1994, 1998, and 2002, winning 13 medals, including 12 gold, making her one of the most decorated athletes in US Ski Team history.

# 9

# COLORADO-BASED SNOW SPORTS BRANDS

**LEATHER MOLITOR BOOTS, C. 1950S.** As skiing advanced, so did its equipment. It should be no surprise that many people from Colorado helped create innovative ski gear and clothing. Companies like Groswold Ski Company, Head, Lange, Obermeyer, Spyder, and Volant all have a connection to Colorado and improved skiing around the world. Gone are the days of skiers using a single pole, nine-foot-long wooden skis, leather lace-up boots, and leather bindings.

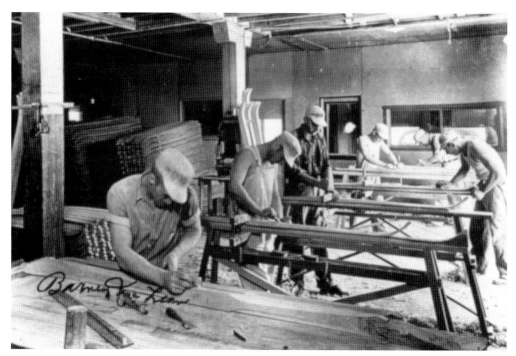

GROSWOLD SKI FACTORY, C. 1930S. In 1932, with the help of Ned Grant and Marcellus Merrill, Thor C. Groswold Sr. established the Groswold Ski Company, originally located at Thirty-Eighth Avenue and York Street in Denver. Soon, this company was recognized as the manufacturer of America's finest handmade hickory skis. The company supplied the 10th Mountain Division with skis during World War II and furnished skis for the 1952 US Ski Team. Many of the ski models were designed by and named for famous skiers of the era, including Barney McLean (shown in the foreground above) and Dick Durrance. Groswold Ski Company closed in 1952.

**GROSWOLD AT BERTHOUD.** Thor Groswold, born in Norway, was a longtime Denver resident who became a true promoter of Colorado skiing. During the 1920s, he was a constant winner of Colorado's ski jumping competitions. In 1932, he was pulled away from competition when he started Groswold Ski Company. His skis were used by pros and amateurs alike. As a skier himself, Groswold knew what he was looking for to make perfect skis. In addition to his impact on ski equipment, he was also instrumental in the establishment of Berthoud Pass and Winter Park, as well as a co-founder of Arapahoe Basin.

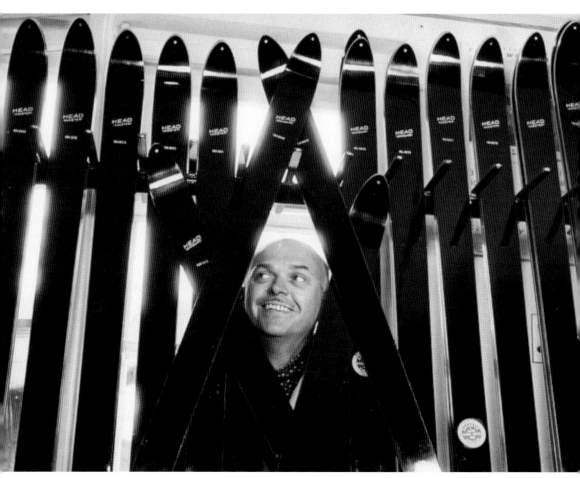

**HEAD WITH STANDARDS, C. 1960.** In the late 1940s, aircraft engineer and amateur skier Howard Head found himself frustrated with the wooden skis of the era and set out to make a better product for skiers. He rented shop space in Maryland and produced an aluminum ski sandwiched around a core of honeycomb plastic. With Head's skill and tenacity, that ski evolved into a triumph of performance and durability. In 1947, Head created the first commercially successful aluminum laminate skis. In 1950, he founded his own firm, Head, which continues to be one of the largest manufacturers of skis and tennis rackets. Head devoted much time and energy to Colorado's ski world. He was an early investor in Vail, where his efforts and financial backing established the Howard Head Sports Medicine Center in 1987. His residence in Vail Village stood at the base of the International runs. One of those runs is now named Head First, which honors the man whose creativity made skiing a delightful experience for thousands.

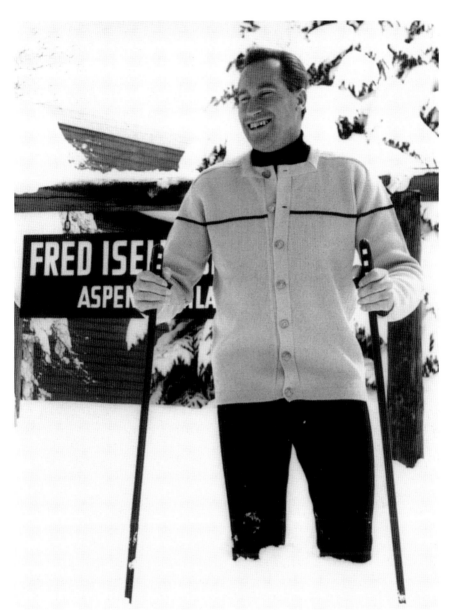

OBERMEYER AT ASPEN, C. 1947. Bavarian-born Klaus Obermeyer started skiing on homemade runners made from a wooden citrus crate at age three. He became an engineer in automobile and aircraft manufacturing and left Germany in 1947 for America. He arrived in Aspen via Sun Valley, and through various travels with movie mogul Warren Miller, teaching skiing for $10 a day for Friedl Pfeifer. Obermeyer soon discovered his students were uncomfortable with the quality of their clothing, and in 1947 he founded Sport Obermeyer. His innovations include the down ski parka, high-altitude suntan lotion, nylon wind shirts, mirrored sunglasses, and much more. His passion for quality and public relations has resulted in a multi-million-dollar company that remains on the top of the market. On December 2, 2022, Klaus Obermeyer celebrated his remarkable 100th year of skiing.

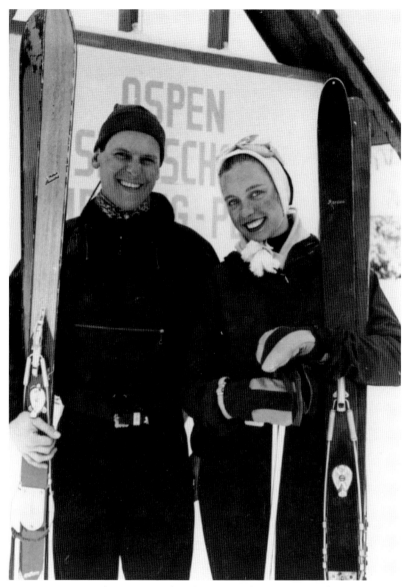

**LANGE WITH WIFE, 1950.** Robert Lange is best known as the inventor of the first injection-molded plastic ski boot, providing more support around the ankles and calves, better control, and flexibility. Lange conceived the idea to make boots in 1955 because he was tired of his leather Molitor ski boots not fitting the way he thought they should. Between 1956 and 1966, he also invented and patented the first fiberglass/leather ski boot, the first thermoplastic ski boot, the first self-molding inner boot, the first plastic ski boot with a hinged upper, the first ski boot that had a sole the width of a ski, the first brightly colored plastic ski boot, the first ski boot buckle with micro screw adjustment, and more. At the 1968 Olympics in Grenoble, 72 percent of the competitors wore Lange boots, and five won medals. In 1968, Lange introduced the Competite: the first ski boot designed specifically for women. In 1970, he patented the first slalom ski with a fixed or removable offset tip, and in 1972, he patented the first plastic boot with a flex-cut sole.

**DAVID L. JACOBS.** David Jacobs began skiing at age 13 and became an avid ski racer. After retiring from racing, he went on to coach. From 1966 to 1969, Jacobs was president of Lange-Jacobs Inc., the manufacturer of Lange plastic ski boots. After that company merged with Lange USA in 1969, Jacobs moved to Boulder, sat on the board of directors, and was the company's vice president from 1969 to 1972. He designed the first Lange competition ski boot, which became the hallmark of World Cup boots. In 1972, he founded the Jacobs Corporation, producing Hot Gear, a line of children's ski clothing. In 1978, Jacobs founded the Spyder brand in Boulder. It began as a small mail-order business and became a multinational ski apparel giant. As the desire for high-end skiwear and high-tech items spread to recreational skiers, Spyder's sales flourished, and Spyder's Boulder headquarters remained at the forefront of technical apparel markets. Spyder was the official apparel partner for the US Ski Team from 1989 until 2022.

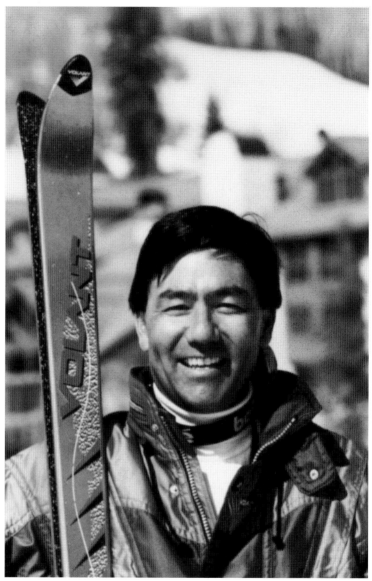

**KASHIWA WITH SKIS, C. 1989–1990S.** Brothers Hank and Bucky Kashiwa founded Volant Ski Corporation out of Boulder in 1989. The brothers developed the stainless-steel cap ski and founded the company with the belief that stainless steel skis would provide better performance than skis made from other materials. The design was developed by Bucky Kashiwa, an engineer at the Los Alamos National Laboratory in New Mexico. By 2003, the company was sold and left Colorado, but the brothers purchased Boulder's trendsetting brand Aggression Snowboards in 1994 to acquire a snowboard manufacturing facility. A steel-capped snowboard was introduced to the Aggression line (the Aggression Steel). In the following season, Volant introduced its own line of snowboards and shifted the steel-capped boards to the Volant line. Volant purchased Limited Snowboards, bringing its president to Wheat Ridge but continuing to produce the Limited line in Canada. Unfortunately, Volant struggled to turn a profit and the snowboard company eventually closed.

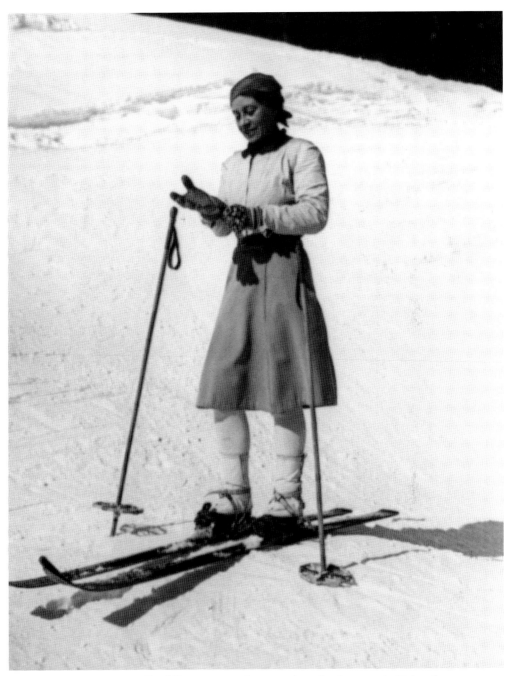

**FASHIONABLE ELLI ISELIN.** The following pages focus on the role of women in Colorado snow sports fashion, clothing, and brands, as they played an early and important part in skiing innovation and marketing. Fashion advanced skiing by illustrating the beauty of the Colorado mountain style and making it globally recognizable and desirable. Women in the industry ensured that skiing was a sport for both men and women, inspiring the next generation of female skiers. The women celebrated here are not only known as fashion icons, but also as excellent skiers.

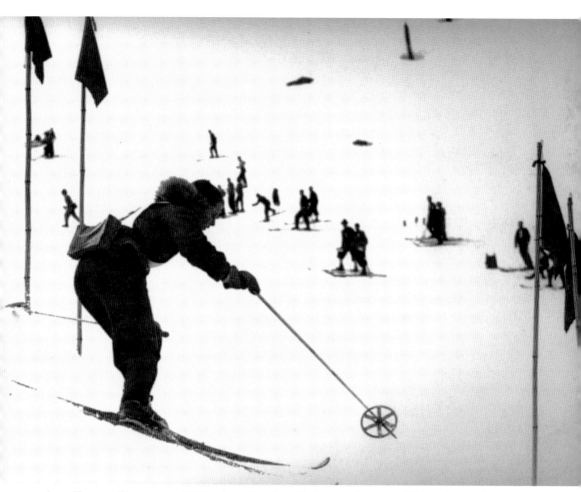

ANN TAYLOR RACING, C. 1930S. Ann Bonfoey Taylor was born in 1910 in Pennsylvania to a wealthy family that owned Putnam Dyes. From an early age, she was extraordinary. When she was six years old, her father introduced her to flying. At 18, Taylor moved to Vermont, took up skiing, and acquired the nickname "Nosedive Annie." After graduating from a prestigious boarding school in upstate New York, where she embraced athletics and excelled in everything from tennis to dressage, Taylor married James Cooke. In 1940, she was named an alternate to the US Ski Team, but due to the onset of World War II, the Olympics were canceled. Taylor and Cooke divorced shortly thereafter. To support herself and her children, Taylor turned to her skill of flying. In 1941, she enrolled as an aviation major at the University of Vermont and quickly earned her wings as a commercial flight instructor—one of just 25 women qualified in the country at the time. (Courtesy of the Taylor family.)

**HANDMADE CLOTHING, C. 1960S–1970S.** During World War II, Ann Taylor became a flight instructor for Army and Navy pilots. Following the war, she launched her own clothing label, Ann Cooke, a line of distinctive homemade skiwear and innovations that included the first fanny pack. She sold distribution rights to Lord & Taylor, which featured her clothing in window displays on Fifth Avenue in New York City and in 20 other stores. In 1947, she married Vernon "Moose" Taylor, the love of her life. To be closer to the mountains, the couple relocated to Denver in 1951. No longer designing clothes herself, Taylor became a collector, amassing 4,500 pieces from many of the world's greatest fashion houses. She had an elaborate set of costumes for skiing, which she accessorized with military influence and cultural or regional accoutrements. (Both, courtesy of the Taylor family.)

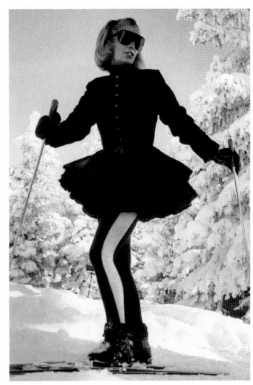

SKIING IN COLORADO

**THE TAYLORS, C. 1950S.** As one of the founders of Vail in 1963, the Taylors built one of the first ski chalets in the new town. Ann Taylor used her iconic style and her connections in New York and abroad to put Vail on the map. The Taylors quickly became known for their hospitality. Ann was renowned for her attention to detail and proper etiquette. She was featured in publications like *Harper's Bazaar, Town and Country,* and *Vogue* from the 1930s to the 1970s. The Taylors skied and entertained in their chalet in Vail until her ninth decade and moved back to Denver in 2005. She passed away in 2007. Ann Taylor carried herself like royalty because, in Vail, that is precisely what she was. (Courtesy of the Taylor family.)

**ISELIN SKIING.** Elli Iselin helped put Aspen on the map. She became an accomplished mountaineer and skier at an early age, eventually competing on the Austrian national ski team. She immigrated to the United States in 1939 and met her husband, Fred Iselin, in Sun Valley. The two soon found their way to Aspen, where they became a vital part of the ski community. Elli Iselin was one of the first women to teach skiing at Aspen, and in 1954, she opened Elli's of Aspen, a store that introduced Colorado to the ski fashions of Europe. Iselin had a great eye for fashion, importing Bogner and Lanz, and designing her own ski clothing. Aspen soon became the epicenter of ski fashion in North America, with Elli's of Aspen leading the way. Iselin's sense of style and Bavarian influence inspired generations of skiers.

SKIING IN COLORADO

GORSUCH RACING, 1956. One of the top women racers on the US Ski Team, Renie Gorsuch made her Olympic debut in 1960. While racing for the team, she met her future husband, David Gorsuch. The couple started a small ski retail store in Gunnison that would go on to define the industry. Renie Gorsuch worked tirelessly to create a sense of fashion for the sport. Bringing mountain elegance and a refined fashion sense to the slopes was no easy task in the formative days of skiing, but Gorsuch Ltd. soon became a standard for the ski industry with stores throughout Colorado. Under Renie Gorsuch's direction and using the grandeur of the Colorado Rockies as a visual backdrop, the store's catalog introduced millions of people around the nation to the beauty of Colorado and mountain living. She embraced both the sport of skiing and the mountain lifestyle and sold countless people on the beauty of Colorado ski country. Gorsuch ski shops expanded to locations in Vail, Beaver Creek, Keystone, and Aspen.

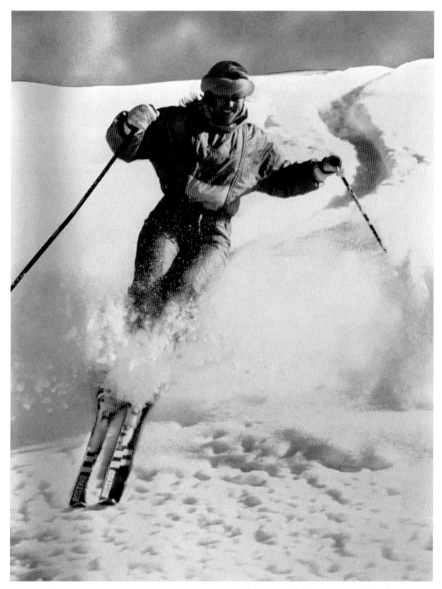

DIANE BOYER SKIING, C. LATE 1970S. Diane Boyer discovered her passion for skiing at an early age, skiing with her parents in Bromley, Vermont, at the age of four. But when she moved to Vail in 1977, she never looked back. Boyer is a passionate Colorado skier and outdoor enthusiast, actively promoting skiing for women and families through her company SKEA Ltd. and her involvement in SnowSports Industries America (SIA) and the Colorado Snowsports Museum. The Boyer family founded SKEA in 1972, with Diane at the helm as president since 1992, along with serving as designer and owner for decades. From her home base in Vail, Boyer's Colorado and national industry influence are borne of her tenure on the SIA board of directors (1998–2009), including serving as the first female chair of SIA from 2005 to 2007. From 2005, Boyer was instrumental in convincing the SIA board of directors, City of Denver, and State of Colorado to move the annual January ski industry trade show from Las Vegas to Denver in 2009.

**THOREN AT FACTORY, C. 1986.** Jeannie Thoren is a skier with a mission—a crusader for women skiers—to create equipment to fit women according to their body type. For the past four decades, she has been perfecting skis and boots to enhance women's ability to ski. The Thoren Theory evolved to help women skiers radically improve their technique through equipment modification. In 1986, she built the first women's specific ski featuring a forward binding location in the Blizzard factory in Mittersill, Austria. In 2005, Dynastar/Lange hired her to perfect the Dynastar Exclusive Carve Ski, which won the 2007 Gear of the Year Award. In 2009, she opened Vail's first women's ski shop. Through her dedication, tenacity, and perseverance, Thoren has elevated the skiing experience for women across Colorado and the world. (Both, courtesy of Jeannie Thoren.)

# 10

# COLORADO COMPETITION CHAMPIONS

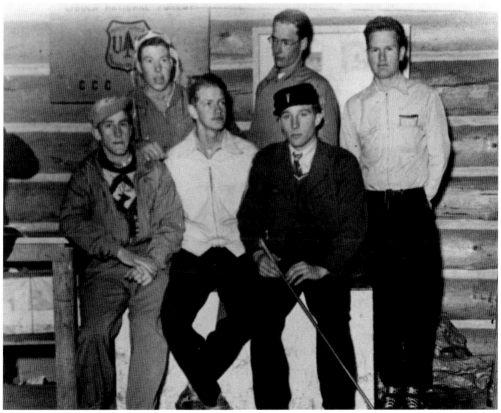

**WESTERN SKI TEAM, 1946–1947.** Colorado has led the way in producing ski champions. Skiing is a way of life here, not just a recreational activity. The Colorado athletes celebrated in this chapter represent ski jumping, Nordic, and Alpine pioneers. This photograph shows the Western Colorado University Ski Team (from left to right): (first row) Don Larsh, Thor Groswold, and Crosby Perry-Smith; (second row) Paul Wegeman, Herbert Snyder, and Fred Pearce.

**HENRY HALL WITH TROPHIES, C. 1910S.** A unique chapter in Colorado's rich skiing history belongs to one of America's first great ski jumpers, Henry Christian Hall. He was introduced to the sport at an early age, using skis made from barrel staves. He set the Ironwood Hill record at age 17 and won many amateur records. In 1913, he captured the world amateur record and the national amateur record the following year. In 1916, Hall joined the Steamboat Ski Club. In 1917, he became the first person to break the 200-foot ski-jumping barrier with his 203-foot jump at Howelsen Hill. He was the first American to ever set the world record in ski jumping. Church bells rang and Hall was carried through town on the shoulders of citizens, while fellow jumpers carried the American flag. It was a historic day for American skiing.

**An Older Hall.** In 1921, after serving in World War I, Henry Hall returned to ski jumping and reclaimed his world record by jumping 229.5 feet. In 1923, prior to the first US Ski Team, he started building ski jumps of record heights and organized National Ski Association–sanctioned tournaments at three locations in Michigan until 1936, when he suffered serious ski injuries. Hall's enthusiasm for skiing captured the media's attention and he donated his expertise to skiers of all ages and skill levels. He continued jumping on his backyard ski jump until his final jump in 1972 at the age of 79; at the age of 92, he was honored to ski the landing at the Steamboat Springs Winter Sports Carnival. Hall passed away in 1986.

**James Harsh.** James Harsh was born in Molina, Colorado, in 1909, carrying on his family's long history of Colorado residency, which began in 1859. Harsh's father presented him with a pair of yellow pine Strand skis when he was nine, and he learned to use them on the ranch and around Hot Sulphur Springs. Harsh's competitive record began in 1917 at the annual winter carnival. Each year, he placed high in the standings. At the Colorado Agricultural School in 1929, Harsh developed campus interest in skiing and organized a ski club, serving as its first president in 1932. Also in 1932, because of his strength in jumping and cross-country, he was named to the US Olympic team as an alternate, becoming one of Colorado's first Olympic team members. Harsh reactivated the Estes Park Ski Club after moving there in 1946; the club rebuilt the old jumping hill and hosted meets.

**SKI JUMPERS, 1919 (ABOVE) AND 1920.** Anders Haugen, a native of Telemark, Norway, came to America in 1908. While calling Dillon, Colorado, his home, he won many ski jumping honors, including two US professional titles and two amateur titles. In 1919 and 1920, he set successive world ski jumping records at the Dillon ski jump, with measures of 213 and 214 feet, respectively. Haugen was captain of the first US Ski Team in 1924 and won the nation's first Olympic skiing medal, a bronze, in Chamonix, France, that year. Ironically, a judging error prevented him from receiving his medal for 50 years, but it was finally awarded to him at the age of 86 in Norway in 1974. Above, Haugen is third from left. The photograph at right shows him breaking the 1920 world record.

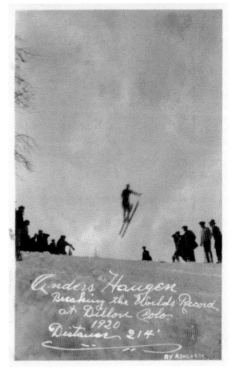

SKIING IN COLORADO

105

**ED COUCH.** Ed Couch began skiing at an incredibly early age, on mail-order skis from Montgomery Ward. In 1913, after a record snowstorm paralyzed his hometown, Couch's father made a pair of pine skis for himself to enable him to get food to the horses and cows on the ranch. Skiing was not only fun but functional, since they often skied to school, learning to turn through the pines.

**COUCH AND JOHNSTONE.** When the Couch family moved to Dillon in 1915, skiing was a way of life with the children there. Ed Couch learned the rudiments of ski jumping. Representing the Denver Ski Club and then Denver University, he placed or won in major ski meets from 1923 to 1929. Bob Johnstone was a ski patrolman and was on the board of trustees at Winter Park.

COLORADO COMPETITION CHAMPIONS

**SORENSEN AND COACHES, C. 1968.** Harald "Pop" Sorensen got into competitive skiing at the age of 13 before immigrating to America in 1929. He was a two-time member of the NSA's All-American ski team and was a runner-up at the ski jumping national championships twice. His skiing prowess led him to a distinctive military career, teaching skiing to troops in the United States and abroad. In 1946, Sorensen began his famous jumping program for the *Denver Post* at Winter Park. Free to kids, the program led them through a series of hills, culminating in a 60-meter jump. His coaching influenced such jumping greats as Torger Tokle, Art Devlin, Jay Rand, and the Perry-Smiths. Sorensen's personal achievements include the Halstead Memorial Award in Colorado and induction into the National Ski and Snowboard Hall of Fame.

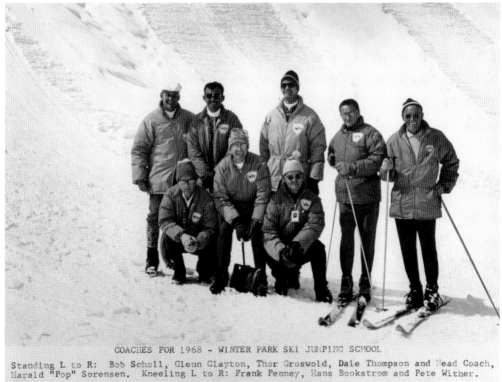

COACHES FOR 1968 - WINTER PARK SKI JUMPING SCHOOL
Standing L to R: Bob Scholl, Glenn Clayton, Thor Groswold, Dale Thompson and Head Coach, Harald "Pop" Sorensen. Kneeling L to R: Frank Penney, Hans Bookstrom and Pete Wither.

SKIING IN COLORADO

**BARNEY MCLEAN.** Robert "Barney" McLean was born in Wyoming in 1917. Before he was four, his family moved to Hot Sulphur Springs, where he almost immediately put on homemade skis and was nicknamed for a local bow-legged Irish jumper. He won his first prize at the age of 13 when he won the Western boys jumping championship. After winning the national Class B jumping championship in 1935, McLean switched to Alpine skiing and began collecting a series of awards that eventually included every major race in North America. His achievements were perhaps best represented by the year 1947, when he was awarded the National Ski Association's All-American Ski Trophy for his contribution to the sport, the Halstead Trophy of the Southern Rocky Mountain Ski Association for the same reason, and the Robert Russell Memorial Trophy as Colorado's outstanding athlete of the year—the first time this was ever given to a skier.

**CROSBY PERRY-SMITH.** Crosby Perry-Smith won the national jumping championship when he was only 14 years old. He served in the 10th Mountain Division and returned to civilian life at Western State College in Gunnison, where he organized the college ski team and continued winning collegiate, regional, and national events. He remained involved in sports after his competitive years, coaching junior jumpers at the Winter Park Jump School for 16 years. He received the Halstead Memorial Award in 1983, and in 1985, coached the US jumping team at the World University Games. Perry-Smith is highly regarded not only as a dedicated and popular coach, but also as an inspiring leader in the skiing community.

SKIING IN COLORADO

ERICH WINDISCH, C. 1957–1960s. Windisch started skiing in his native Germany at the age of three and won his first race at age seven. In 1949, he was instrumental in the evolution of ski jumping, changing the forward arm position to a more aerodynamic position alongside the body. This technique is still in use today. Windisch's best jump was 337 feet at Oberstdorf in 1950. Also in 1950, he held the world record in water ski jumping. In 1957, he moved to Colorado and became co-director of the Willy Schaeffler Ski School at Arapahoe Basin. While there, he made an immediate impact by introducing the short-swing (wedel) technique that was soon adopted by the Professional Ski Instructors Association.

**WREN AT STEAMBOAT, 1948.** A native of Steamboat Springs, Gordon "Gordy" Wren took to skiing as naturally as most kids take to ice cream. By the time he graduated from high school, he was already a frequent champion, at first in jumping and later in Alpine events. After four years in the 10th Mountain Division, he resumed competition by qualifying for all four events in the 1948 Olympics, placing fifth in Olympic special jumping at St. Moritz. His amazing versatility was most apparent in 1950 when he jumped with the FIS team, took first place in the national Nordic combined championships, and second in the national giant slalom championships. Wren was the first American to jump 300 feet. His special interest in teaching youth led him to coach at Steamboat Springs from 1955 to 1959. He also assisted Frank Bulkley with the formation of Denver's Eskimo Ski Club.

**TED FARWELL.** Ted Farwell took up skiing early, organized his high school ski team, and went on to ski for Syracuse University. After moving to Colorado, he starred in Nordic combined and cross-country skiing, representing the Steamboat Springs Winter Sports Club and Denver University in the 1950s. He skied on the US Olympic teams in 1952, 1956, and 1960. At the 1952 Olympics, he placed 11th in the Nordic combined, the highest finish for a native-born American until 2002, when Todd Lodwick placed seventh. Following his competitive years, Farwell served as a consultant to ski area developers and developed the procedures and format for the Annual Economic Analysis of North American Ski Areas.

**Norton R. Billings.** Norton Billings was born in 1904, near Lyons, Colorado. Early in life, he learned to cross-country ski. He and his friends regularly skied over the Continental Divide from Estes Park to Grand Lake. He entered many regional cross-country ski competitions and was seldom outdone. Most of his skiing was as a member of the Rocky Mountain National Park Ski Club. Billings won the club's Elkhorn Trophy by finishing first in annual competitions in 1924, 1925, and 1926. After he married in 1928 and became a father, he did not have the time to compete regularly, yet he was still one of the top cross-country skiers in the United States, and in 1932 was chosen for the Olympic ski team. Unfortunately, snow conditions were poor and Billings splintered the tip of his ski and had to retire from the 50-kilometer competition.

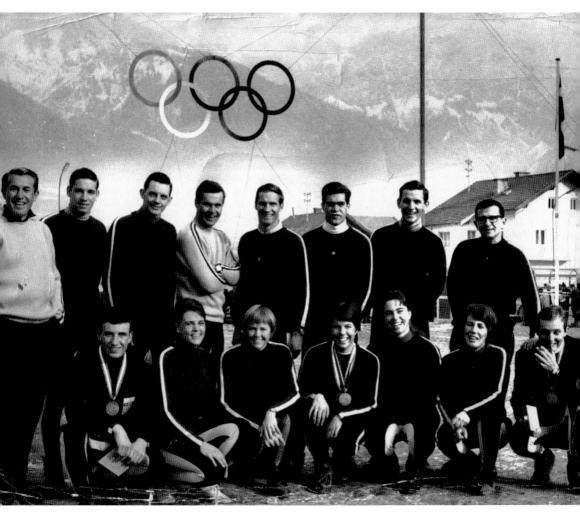

**OLYMPIC ALPINE TEAM, 1964.** The Colorado athletes celebrated in the rest of this chapter, mostly Alpine skiers, set the stage to inspire the next generation of skiers, like the greatest skier of all time, Mikaela Shiffrin, coming out of the Vail Valley. These final pages explore the lives of more Colorado Snowsports Hall of Famers who excelled in skiing.

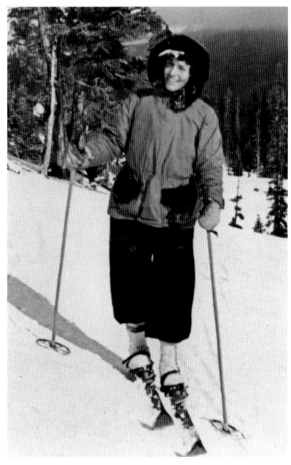

**LOUISE WHITE, 1933 (ABOVE) AND 1937.** Louise White could have been one of Colorado's first Olympic champions, but because her career stretched from 1932 to 1940 when the Olympics were canceled because of World War II, she instead became one of Colorado's finest women skiers. A native of Fort Collins, White fell in love with skiing while teaching at Idledale, in the foothills of the Rockies, in 1931. She began competing in 1932. With the construction of rope tows at Berthoud, Genesee, and Glen Cove, skiing became more widespread, and White rapidly began to make her mark. In 1937, she placed first in the downhill, slalom, and combined at the Amateur Ski Association championship at Berthoud. For the next three years, she continued to win almost every race she entered. White, with other women skiers, founded the first women's ski association, the Colorado Skiing Association.

SKIING IN COLORADO

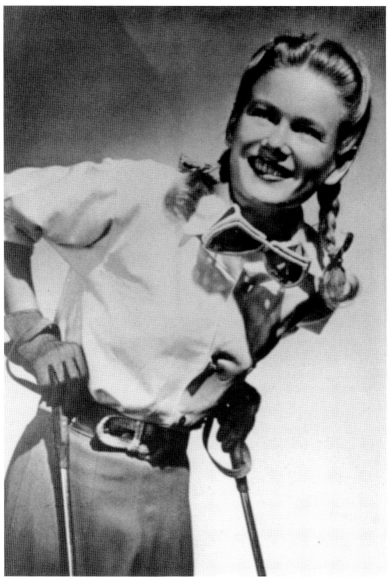

**BARBARA LEE IN GEAR, C. 1940S.** In 1934, at the age of seven, Colorado became home to Barbara Kidder Lee. Her father encouraged her and her siblings to ski by building them skis and poles. Lee did not take to the sport at first but became a believer when she first skied Genesee Mountain. She progressed rapidly and entered her first race in 1940 at Berthoud Pass. At age 14, she qualified for the national championships in Aspen in 1941. She was the Southern Rocky Mountain Ski Association champion in 1942. From 1942 to 1945, she competed only in local races, due to World War II. In 1945, she started skiing for the University of Denver, where she took first place in the downhill and slalom at the intercollegiate ski meet at Winter Park. Through the end of the 1940s, Lee went on to compete nationally with remarkable success. She became known as the "Darling of the Rockies" because of her attractiveness and spunky attitude while competing and was named the Outstanding Woman Skier in the United States in April 1946.

**KATY RODOLPH-WYATT, C. 1950S.** Rodolph-Wyatt was born in 1930. Her skiing career started at age 14 in Steamboat Springs, under the tutelage of instructor and ski coach Al Wegeman. She was named to the US team that competed in the world championships in Aspen in 1950. She sprained both ankles while training but went on to place in the top 10 in all three disciplines. While on the Olympic team in 1952, she placed fifth in the giant slalom. In 1954, she was again named to the national team and placed fifth in the championships. Rodolph-Wyatt continued her racing career, and in 1956, while a member of her second Olympic team, she fractured three vertebrae and was unable to compete. From 1949 to 1956, Rodolph-Wyatt won nine national titles. Back then, it was more difficult to train and race, as competitors often had to climb courses and train with any equipment they could find, often ill-fitting. She and her teammates of that era were pioneers and made racing what it is today.

**SKEETER AND BUDDY WERNER, 1954.** Out of Steamboat Springs, Skeeter Werner-Walker was the oldest of the famous Werner family including Olympians Buddy and Loris. She started her skiing career at the age of one in 1934 and entered serious competitions by fifth grade. In 1949, she came to national attention by winning the West of the Mississippi championships in Sun Valley. For the following two years, she reigned as the queen of the junior nationals circuit, winning at Alta in 1950 and again at Stowe in 1951. Her international career started in 1953 when she became a member of the US national team, placing 10th in the downhill. She retired from competition due to a broken leg in 1957, and in 1961, she returned to Steamboat Springs and started the Werner Storm Hut Ski Shop with Buddy Werner and the Steamboat Ski School, serving as director until 1969.

**BUDDY WERNER AT BROADMOOR, 1961.** Buddy Werner began skiing on Howelsen Hill. He won his first regional championship in jumping at the age of 10. During his formative years, he decided to concentrate on Alpine events and became a three-time member of the US team and a two-time FIS team member. In 1964, his life was tragically cut short when he was killed in an avalanche in Switzerland.

**LORIS AND BUDDY, C. 1950S.** Loris Werner was the youngest member of the Werner family. While attending Western State College, he competed in all four disciplines—ski jumping, cross-country, downhill, and slalom. He won the NCAA Skimeister championship twice and represented the United States at two Winter Olympics, in 1964 and 1968. For more than four decades, he served Steamboat Springs, first as ski school director, then as mountain manager, and finally as vice president of operations.

**CHUCK AND BARBARA FERRIES, 1962.** The Ferries family was another historically significant Colorado ski competition family. The Ferries had four children—all skiers and racers. The following images focus on the accomplishments of Chuck and Barbara Ferries. Chuck had an outstanding career as a US Alpine racer and US Ski Team coach. (Photograph by Margaret Durrance.)

**BEATTIE AND FERRIES.** Chuck Ferries competed for the United States at the Olympics in 1960 and 1964. He became the first American to win a European classic gate race when he won Austria's Hahnenkamm slalom in 1962. After retiring from competition, he served as chairman of the US Ski and Snowboard Association from 2002 to 2006, bringing recognition to the Colorado ski industry. This photograph shows coach Bob Beattie (left) and Chuck Ferries.

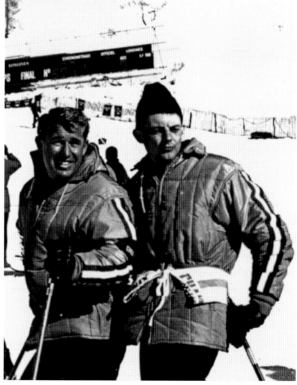

**BARBARA FERRIES HENDERSON, C. 1960S.** Henderson paved the way for the following generations of female ski racers. Winning the US junior national championship in both downhill and combined in 1960 on Aspen Mountain marked the beginning of the career of one of America's great ski racers of the 1960s. She was introduced to skiing at an early age, and followed her brother Chuck to the mountains of Colorado, settling in Aspen. In 1961, Henderson won the Roch Cup in downhill and giant slalom, as well as the Harriman Cup in Sun Valley. She was named to the 1962 US Ski Team and went on to win bronze in the downhill at the world championships in Chamonix, France. At a time when women were not encouraged to compete in the male-dominated sport of downhill skiing, Henderson became one of America's best speed skiers. She represented the United States at the 1964 Winter Olympics with teammates Billy Kidd, Bill Marolt, and Jimmie Heuga.

**YOUNG JIM BARROWS, C. 1940S–1950S.** Jim Barrows of Steamboat came up through the junior ranks. Coached by Gordy Wren, he developed skills in all skiing events. During the 1961–1962 season, he won every downhill race in the Rocky Mountain Division. Barrows became the nation's premier four-event skier, winning several NCAA titles, and was tagged "Moose" by his University of Colorado coach, Bob Beattie. In 1965, he qualified for the US Ski Team, and in 1966, competed in the world championships. In 1967, he finished third in the World Cup downhill and finished the season seventh in the FIS world downhill ranking, the highest American, qualifying him for the 1968 Olympic team. His 1968 season ended abruptly during his bid for Olympic gold in the downhill. ABC's *Wide World of Sports* well documented his spectacular fall. Barrows recovered to win the 1969 North American downhill championships, but 1970 brought another physical setback. He joined the pro tour in 1971 and finished third overall in 1972 and 10th in money earnings.

**BILLY KIDD AND JIMMIE HEUGA.** Billy Kidd (silver) and Jimmie Heuga (bronze) were the first American men awarded Olympic Alpine skiing medals at the 1964 Winter Olympics. Both men remain inspirations in the Alpine ski world. Kidd (right) was a member of the US Ski Team from 1962 to 1970. He also won the gold medal in the combined at the 1970 world championships. Heuga (below) competed internationally on the US Ski Team for 10 years. He was also third in the 1967 World Cup giant slalom. In 1967, he was diagnosed with multiple sclerosis. He later moved to Vail and founded the Jimmie Heuga Center, now known as the Can Do Center, for physical conditioning and consulting services to people with disabilities and personal challenges.

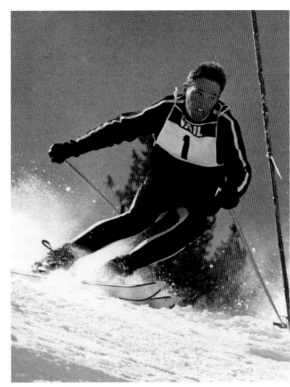

SKIING IN COLORADO

BILL MAROLT. Marolt was raised in Aspen in one of America's most famous skiing families and rose quickly through the junior ranks. While a scholarship student at the University of Colorado, he became an All-American member of the world championship US Ski Team from 1962 to 1966. At the 1964 Olympics, he finished 12th in giant slalom. He was then named the University of Colorado ski team coach, molding the program into a dominant power, with seven NCAA championships during his 10-year tenure while coaching 30 All-Americans. As Alpine director of the US Ski Team, he guided the team to five medals in the 1982 world championships, and another five (including three gold) at the 1984 Olympics. Under his direction, American skiers won four individual World Cup championships and 50 separate race victories.

**SPIDER SABICH, 1961.** Vladimir Peter "Spider" Sabich Jr. was born on January 10, 1945, in Sacramento, California. His lifelong nickname was given to him by his father because of his thin arms and legs at a premature birth. Sabich came to Colorado in 1962 to race for Bob Beattie at the University of Colorado. He soon established himself as one of the best American ski racers of his time until his premature death in 1976. This photograph shows Sabich in 1961 at Sun Valley, just before winning first place in slalom.

**SABICH COMPETING, C. 1960s–1970s.** Spider Sabich represented the United States at the 1968 Winter Olympics in Grenoble, France, finishing fifth in the slalom. After three World Cup wins, Sabich moved on to the pro ski racing circuit. In 1971, he won the world pro skiing championship and defended his title, winning again in 1972. Sabich had 18 top-10 finishes in Olympic and World Cup competitions: two in downhill, three in giant slalom, and thirteen in slalom. Spider Sabich's charisma and flamboyant style drew media attention to the sport and promoted the growth of skiing and racing through the 1970s in Colorado and globally. Today, he continues to inspire.

# ABOUT THE ORGANIZATION

Founded in 1975 and located in Vail, the Colorado Snowsports Museum and Hall of Fame's mission is to celebrate Colorado snow sports by telling stories that educate and inspire others to seek adventure.

Our growing artifact collection defines who we are and why we are as Colorado snow sports enthusiasts. Celebrating these stories is vital to preserving the legacy of our sport. The priceless artifacts we collect and display tell the story of the birth, rise, and explosion of skiing and snowboarding in Colorado. The museum features displays such as "Climb to Glory" about the 10th Mountain Division, "Skiing Through Time," the Colorado Snowboard Archive, and the Colorado Snowsports Hall of Fame, among others.

Learn more and consider supporting the museum at snowsportsmuseum.org.

# Discover Thousands of Local History Books
## Featuring Millions of Vintage Images

Arcadia Publishing, the leading local history publisher in the United States, is committed to making history accessible and meaningful through publishing books that celebrate and preserve the heritage of America's people and places.

Find more books like this at
**www.arcadiapublishing.com**

Search for your hometown history, your old stomping grounds, and even your favorite sports team.

Consistent with our mission to preserve history on a local level, this book was printed in South Carolina on American-made paper and manufactured entirely in the United States. Products carrying the accredited Forest Stewardship Council (FSC) label are printed on 100 percent FSC-certified paper.